The Hudson
River School

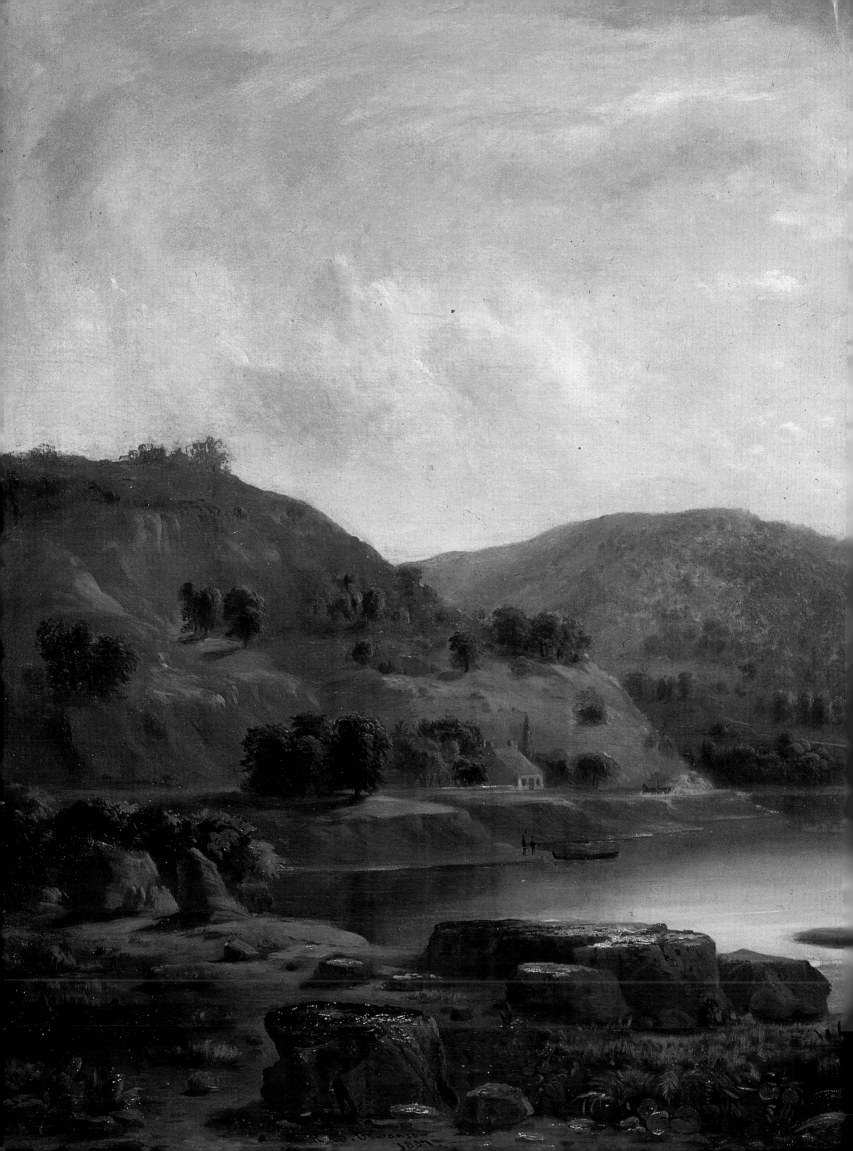

The Hudson River School

Trewin Copplestone

GRAMERCY

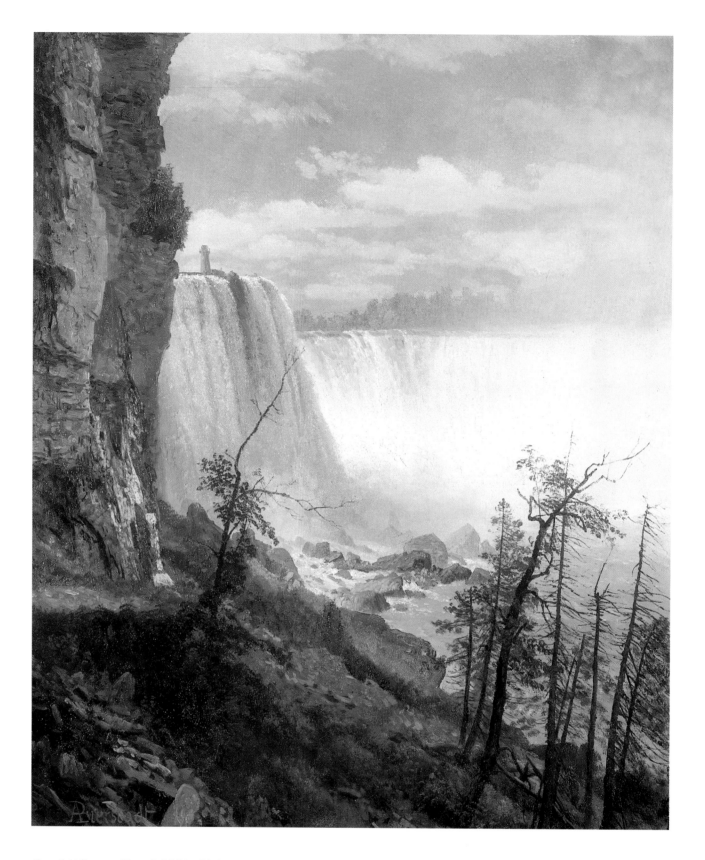

This 1999 edition is published by Gramercy Books™, an imprint of Random House Value Publishing, Inc., 201 East 50th Street, New York, NY 10022

Gramercy Books ™ and design are trademarks of Random House Value Publishing, Inc.

Random House New York • Toronto • London • Sydney • Auckland
http://www.randomhouse.com/

Printed in Singapore

ISBN 0-517-16120-6

10 987654321

List of Plates

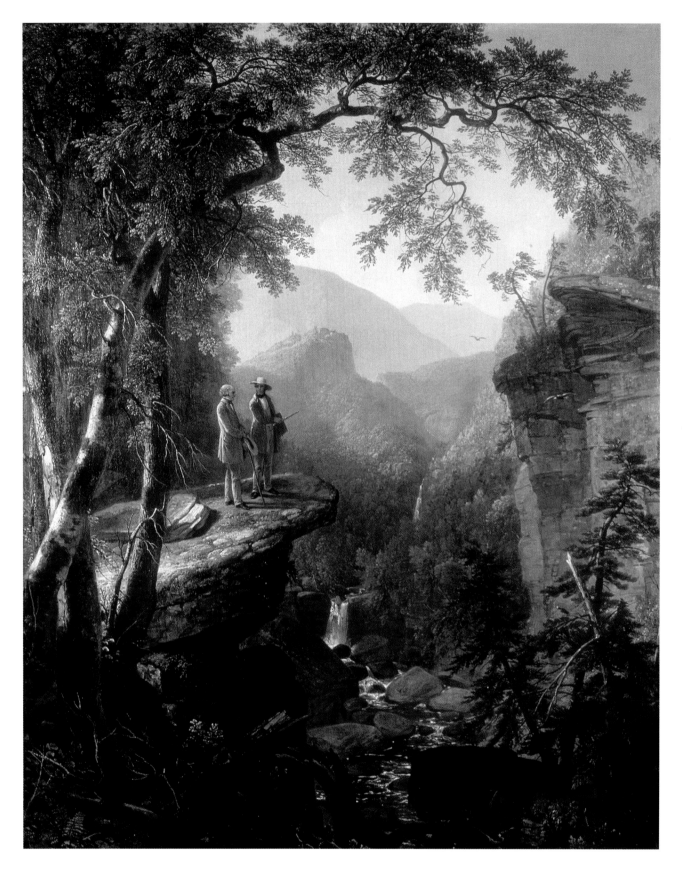

PLATE 1

Kindred Spirits (1849)

Asher Brown Durand (1796–1886)

Oil on canvas, 44 x 36 inches (112 x 91.4cm)

(Courtesy The New York Public Library)

PLATE 2 opposite

Catskill Creek (1850)

Jasper Francis Cropsey (1823–1900)

Oil on canvas, 18¹⁄₂ x 27¹⁄₄ inches (47.1 x 69.1cm)

(Courtesy National Museum of American Art)

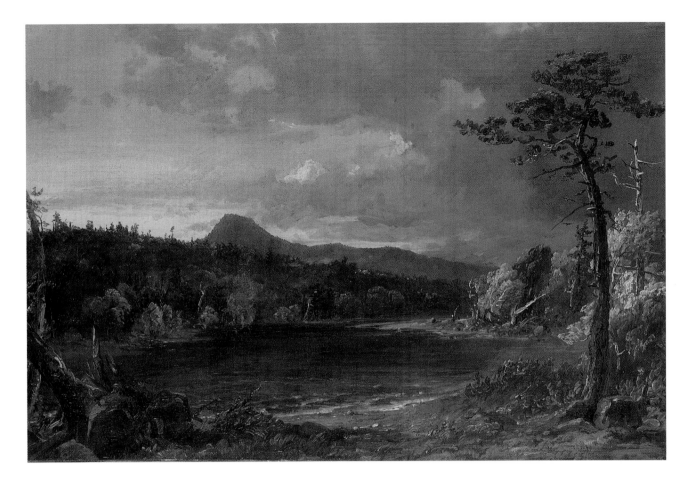

The early history of the United States is principally concerned with the discovery, exploration and settlement of the land, firstly on the Atlantic seaboard and subsequently, from the 16th to the 19th centuries, to the far West, to the Rocky Mountains and ultimately to the western seaboard. The early settlers, almost exclusively from Europe, were motivated by many different aspirations, some from a necessity to improve their condition of poverty, some from a strong sense of adventure, some from religious zeal, others from hopes of riches. From the end of the 15th century and the voyages of Columbus, the European nations had quarrelled and fought over the New World, firstly the Spanish and Portuguese and later the French and British. As a result of the historic voyage of the Mayflower in 1620 a British colony was established at Plymouth, near Cape Cod in New England and the serious colonization of north-eastern America was begun.

As other colonies were established on the eastern seaboard, each desiring its own independent self-government, it was through their combined success and eventual prosperity that the early United States of America was formed in 1783 of the 13 colonies on the east coast from Maine in the north to Georgia in the south. The result was the gradual adoption of the English language as the lingua franca and the focus of the new Americans on the development of their own independent nation. This had been initiated in 1775 by the American Revolution, also known as the War of Independence, in which the Americans achieved independence and separated themselves from the British connection.

While independence was the emotional spur, the role of religion in the early development of the American nation was highly significant. From the first colonies, all the European Christian denominations had been represented in the various nationalities of the colonists. In addition, there were a number of small but growing religious sects whose importance in creating a varied and free religious atmosphere was greater than their numbers would have suggested. A feature of the various Christian groups was an evangelical zeal which expressed itself in a burning desire for the conversion of all non-believers which, of course, included all the native 'Indian' tribes. Although the United States has developed into a predominantly Protestant society, from the very beginning every religion has always been accepted within the broad community. At the same time, a deeply religious conviction was expected in everyone and became an endemic element in the whole culture. It is important in considering the philosophy of the Hudson River School to

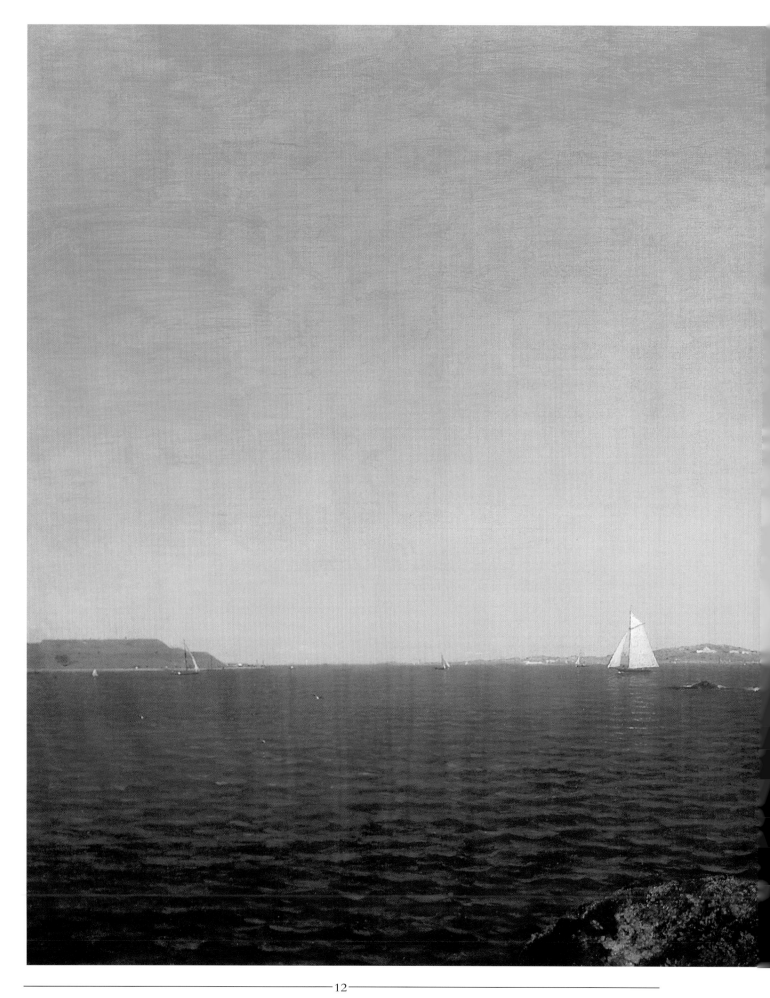

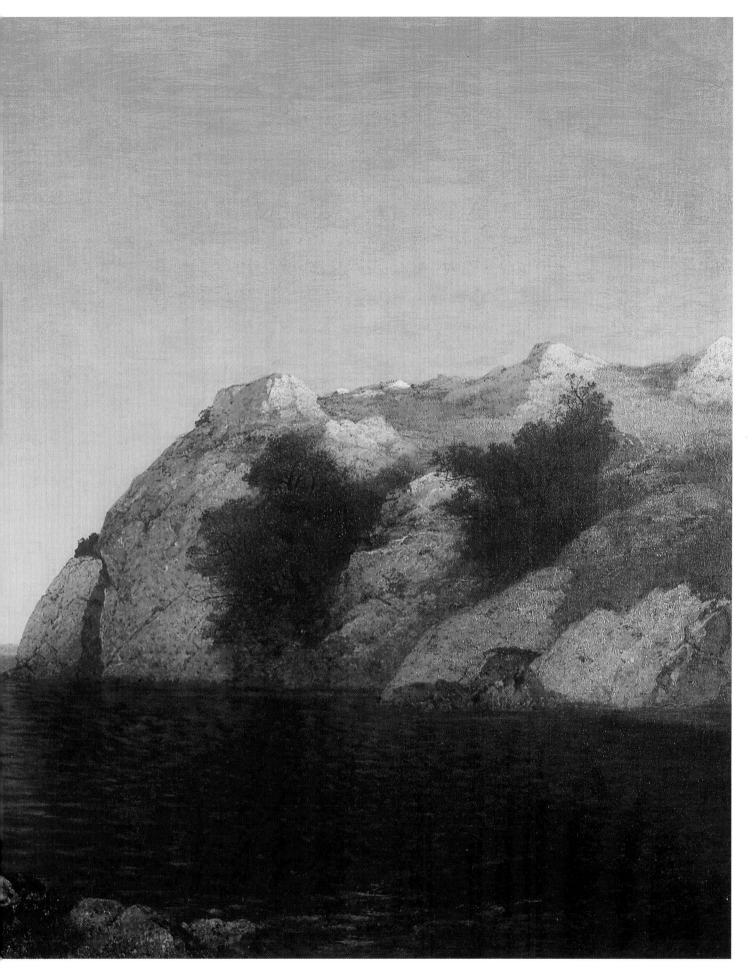

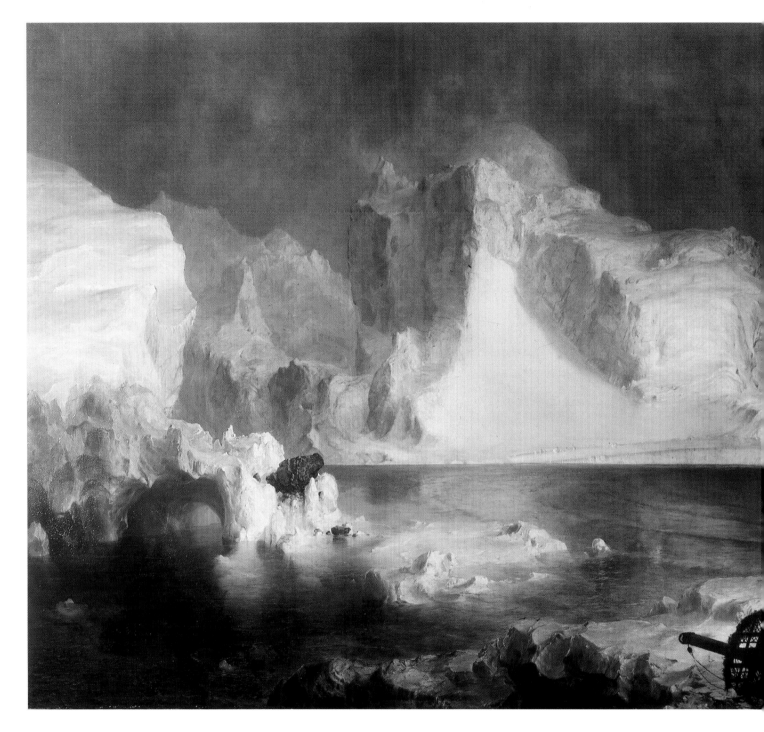

understand how deeply it was underpinned and inspired by religious conviction.

For the above reasons, it is the importance of the two strands of the English language and religious faith in the development of an essentially American culture that created the bedrock on which the independence from Europe and her old civilization was created. It was the beginning of the expression of American values and interests – or at least the hope of acquiring them.

Thus, by the beginning of the 19th century, American culture was still Eurocentric and had to find a distinct identity. Separated from Europe and, as a result of the

Monroe Doctrine in 1823, a new nation not open to colonization, not fighting for self-government, it was able to look to itself and began to realize its size and potential power. It was in this context that the arts began to create their own individual and essentially American artistic heritage.

Painting, until the early years of the 19th century, had either reflected the academic classicism of European art, imported or recreated, or naive painting as undertaken by itinerant artists who roamed the land looking for portrait commissions or with scenes of domestic life to sell. As the 19th century opened, the people were beginning to

Pages 12–13
PLATE 3
Marine off Big Rock (1864)
John Frederick Kensett (1816-1872)
Oil on canvas, 27$^{1/2}$ x 44$^{1/2}$ inches (70 x 113cm)
(The Cummer Museum of Art and Gardens: SuperStock Inc.)

PLATE 4 left
Iceburgs
Frederic Edwin Church (1826-1900)
Oil on canvas
(Private Collection)

a school or movement of painters in the way that one would describe, for instance, the Pre-Raphaelites or the Impressionists. These inclusive titles encapsulate different philosophies and intentions and render the names immediately informative and identifying: the Impressionist painters had a similar philosophy and pictorial intention so that their work is generally identifiable through these characteristics, and they either worked together or were in personal contact with one another. The lives of the Hudson River painters, on the other hand, covered a wide span of time; they did not all paint with any direct or exclusive connection with the Hudson River and its environs, did not all have precisely the same subject interest nor were they all known to one another. In addition, there is no general agreement on who should or could be included as members of the 'School'. What connects them, however unstructurally, is a passionate romantic attachment to the inspiring landscape of the newly discovered and still underexplored continent, together with a desire to imbue the land itself with a spiritual identity. Curiously, too, most of the artists travelled in Europe and the Near East and many of the so-called Hudson River paintings are of such subjects as 'The Wetterhorn' or 'Pompeii' (plates 5, 26, 37 and 38). There is also an apocalyptic character to much of their landscape images uncommon in their peers in contemporary European painting, J.M.W. Turner being the notable exception and consequently much admired by the early Hudson River painters such as Thomas Cole.

In considering the European scene during the middle years of the 19th century, it is important to recall the influence of John Ruskin on most of his contemporaries, including almost all of the Hudson River painters. Through his writings and his critical analysis of the work of many of

discover the great range and variety of the landscape they had inherited and to yearn for an expression of nationhood. The land itself, as well as providing them with a rich potential for national growth, also offered inspiration as an old land with new and varied visual delights to be discovered. It was in this context that the Hudson River School, the first essentially American pictorial movement must be considered.

The Hudson River School is an identifying group title given to a number of mainly landscape painters working in the United States of America in the early and middle years of the 19th century. It is not, as its name appears to suggest,

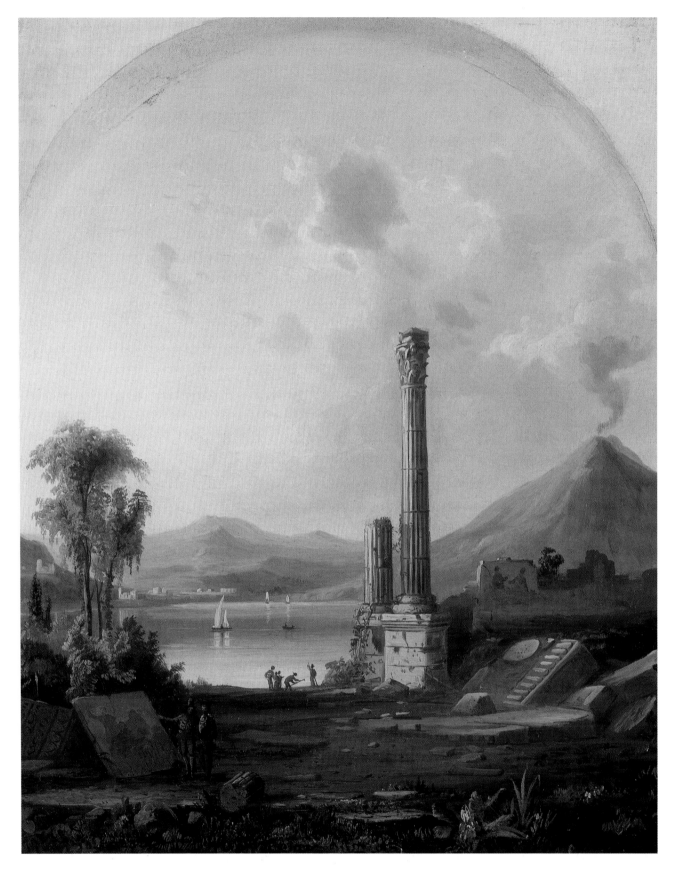

PLATE 5
Pompeii (1855)
Robert Scott Duncanson (1821–1872)
Oil on canvas, 21 x 17 inches (53.3 x 43.2cm)
(Courtesy National Museum of American Art)

PLATE 6 opposite
The Coast of Genoa (1854)
Jasper Francis Cropsey (1823–1900)
Oil on canvas, 48 x 72½ inches (122.4 x 184.2cm)
(Courtesy National Museum of American Art)

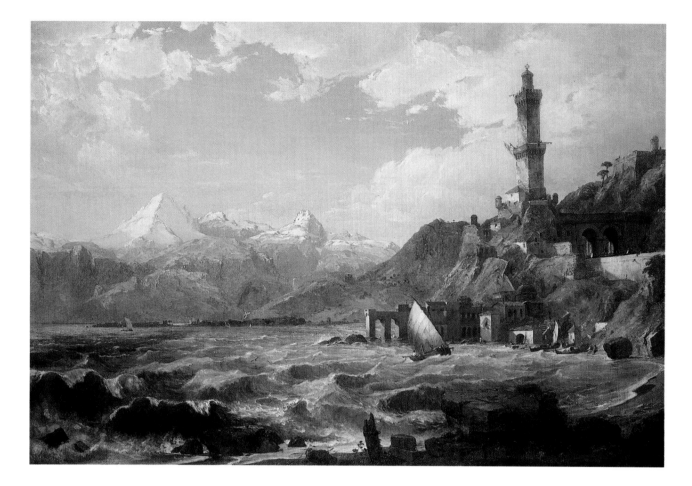

his contemporaries he had achieved an authority as the only guide to the qualities or otherwise of contemporary painting; he was perhaps the first popular art critic whose voice could make or break – and perhaps sadly did. His philosophy which associated and intertwined art, nature and morality became part of the whole social ethos of his age and the Americans, as might be expected from what has been noted above, accepted his teaching with enthusiasm. Ruskin's belief in the higher levels of importance that should be found in art (defining it on one occasion as the 'greatest number of the greatest ideas') became an aesthetic criterion. Almost all the Hudson River painters read him, some met him and were fortified in their transcendental views of the artistic potential to the extent that his views almost achieved the status of an artistic holy writ.

The Hudson River is closely connected with the eastern seaboard of the United States and the growth of the earlier societies of immigrants before the great westward expansion began; but as that expansion progressed, the philosophy that would inspire the early Hudson River painters was initiated by the adventurers and, as the widespread local societies settled and developed, began to produce an art closely related in spirit to the original work of the early painters on the eastern seaboard and particularly those who were centred

on the Hudson River and the surrounding countryside.

In these circumstances it is difficult, if not impossible, to be definitive or exclusive in even the selection of artists and certainly not in choice of subject. However, since any decision in such circumstances is necessarily personal and subjective, it is important to outline the criteria adopted for this survey before embarking upon any analytical consideration.

Although initially inspired by the work of painters who found the Hudson River and the landscape which surrounded it of great variety and excitement it was really, to the settled communities that had grown up there, the whole amazing vastness of the continent spreading westward and immanent with unknown delights and mysteries that was attractive. One of the essential ingredients of the School was thus a romantic attachment to the idea of the infinite variety of the American landscape. Thus, while the area around the Hudson was the first to excite the artists in the early decades of the 19th century, it was quickly expanded in the middle years to the wider panorama as the people moved further westward.

Although the landscape was the initial inspiration, other subject matter was soon included, touching particularly on the lives of the native Americans (still then known as Indians

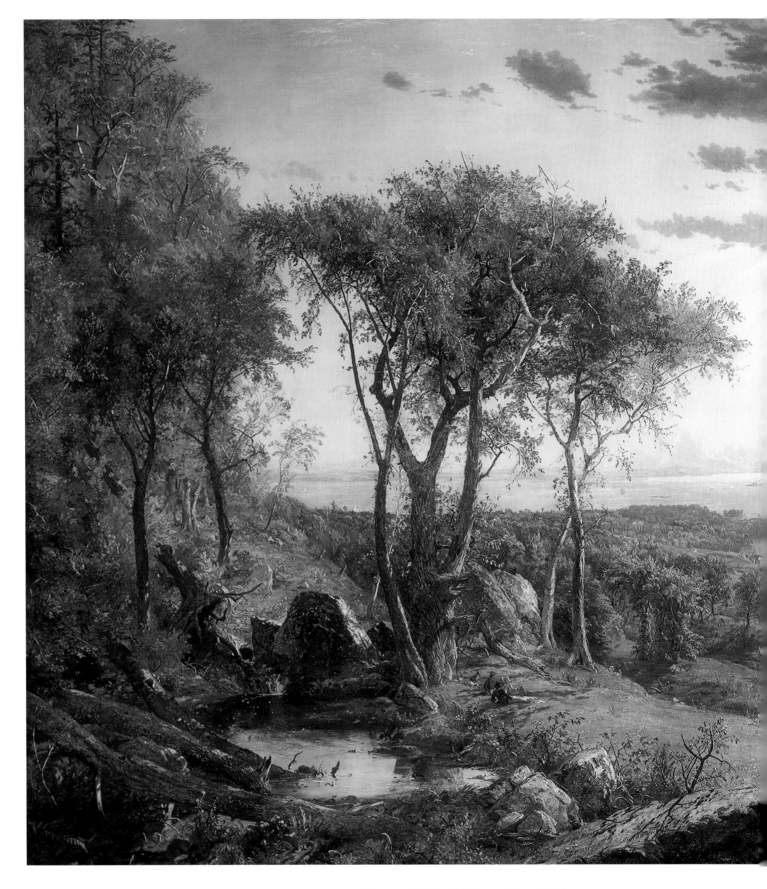

PLATE 7

Autumn – On the Hudson (1860)

Jasper Francis Cropsey (1823–1900)

Oil on canvas, 60 x 108 inches (152.4 x 274.3cm)

(Courtesy National Gallery of Art, Washington:

Gift of the Avalon Foundation)

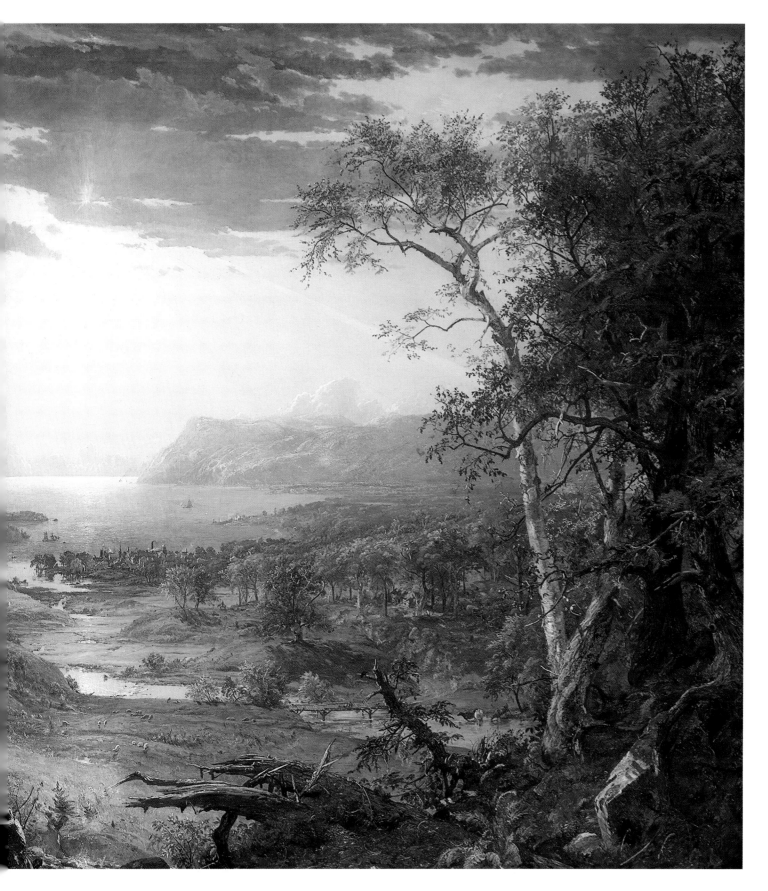

PLATE 8 below

The Lonely Cross – after a poem by Felicia Haymans
Thomas Cole (1801–1848)
Oil on canvas, 24 x 24 inches (61 x 61cm)
(Musée d'Orsay, Paris)

PLATE 9 opposite

View of Niagara Falls from the American Side
Alfred Bierstadt (1830–1902)
Oil on canvas, 9 x 7 inches (22.9 x 17.8cm)
(Private Collection)

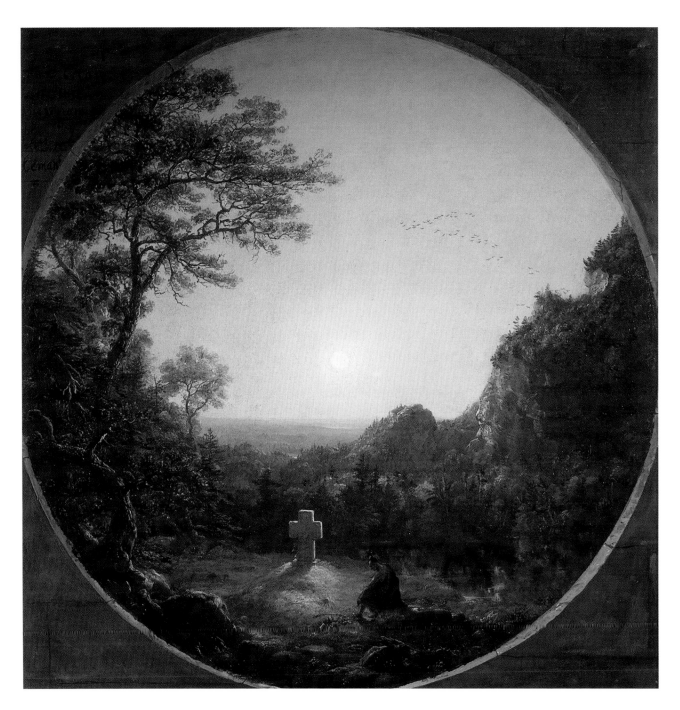

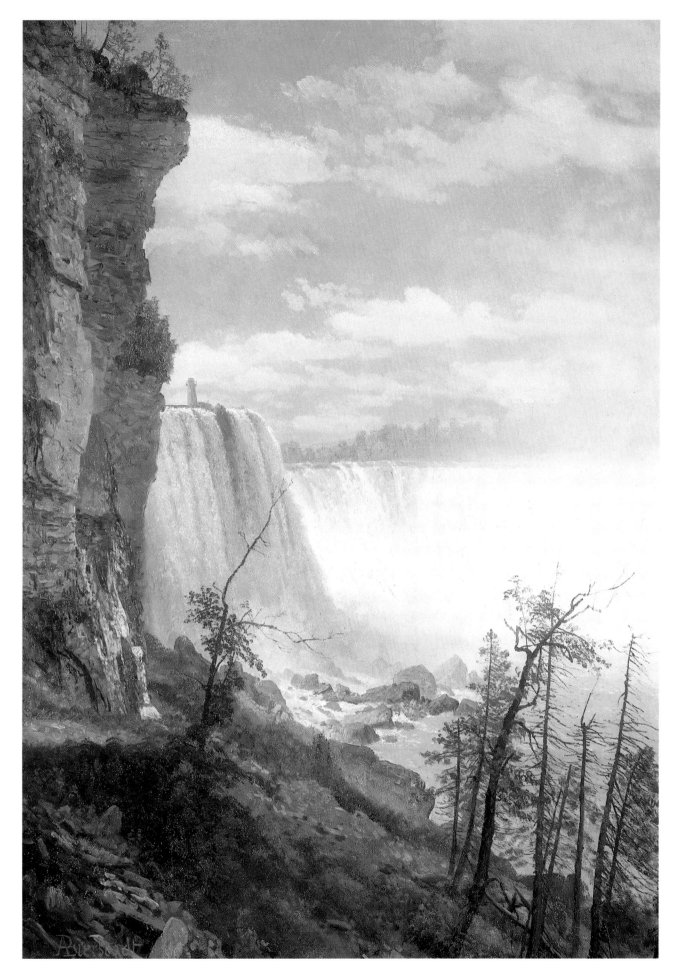

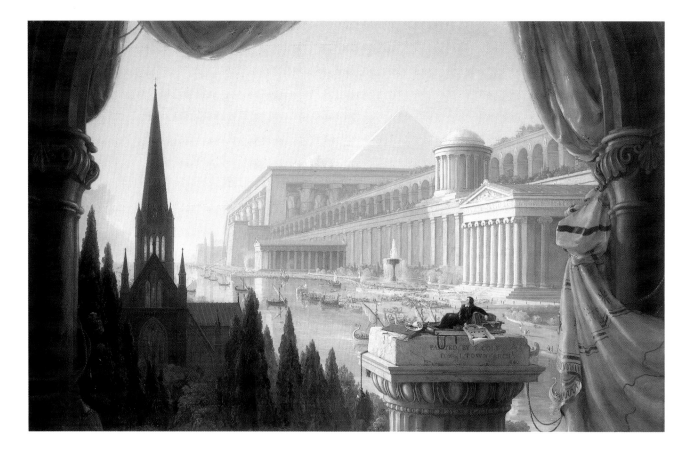

PLATE 10
The Architect's Dream (1840)
Thomas Cole (1801–1848)
Oil on canvas, 53 x 84¹¹/₁₆ inches (134.6 x 213.6cm)
(Courtesy Toledo Museum of Art)

PLATE 11 opposite
Cathedral Forest (1854)
Alfred Bierstadt (1830–1902)
Oil on canvas
(Private Collection)

as a legacy of Columbus' belief that he was discovering the Indies), as well as domestic 'genre' scenes of the new Americans and of their literature. For example, the artist whose name is synonymous with the Hudson River School, Thomas Cole, painted scenes from the Bible and from James Fenimore Cooper's *Last of the Mohicans* during the later 1820s. It is therefore also appropriate to consider such genre subjects as part of the School's oeuvre.

It is also important to remember in any consideration of the work of the School how unformulated was a new national identity by that time. In the lifetime of many of the practitioners or their parents, nationhood had not yet been achieved and great stretches of the subcontinent had still to be fully discovered and settled. The Hudson River painters were to become a significant, if unaware, element in the creation of the cultural character of that national identity.

Romanticism was at the core of the School and this was supported and partly inspired by the contemporary

European Romantic movement of the poets Byron, Shelley and Keats as well as by painters from Delacroix to Turner. Romanticism was a reaction against the academic classicism that had become endemic in European paintings since the discovery of Pompeii and Herculaneum had sponsored a new passion for the classical societies of Greece and Rome following the excesses (as they were then believed to be) of the Baroque artists from Bernini to Boucher and Fragonard. The French Revolution artists, notably Jacques-Louis David, looked to Rome as an inspiration for the pictorial propaganda that would induce a selfless devotion to the new Republic in the citizens of France. The name that identifies this period style is Neo-Classicism and it was against its rigid formulaic painting style, as the Romantics saw it, that they revolted. Their leading painter, Delacroix, looked for his subjects in more exotic locations from North Africa to the Near East. More importantly, his use of drawing, paint and colour was different from the Neo-Classicists' hard, carefully delineated form. It was fresh and

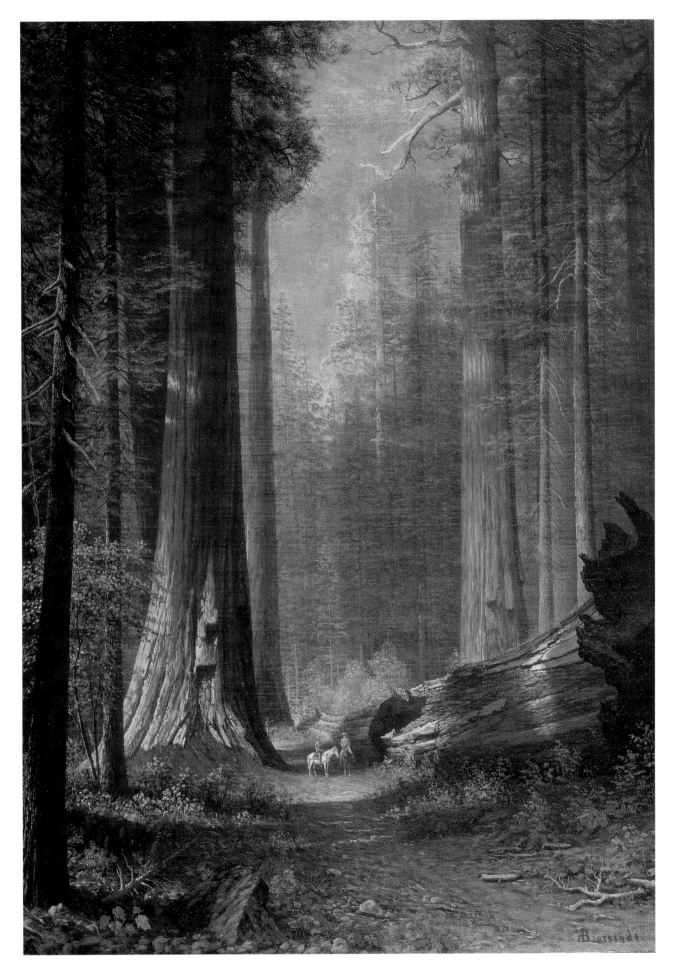

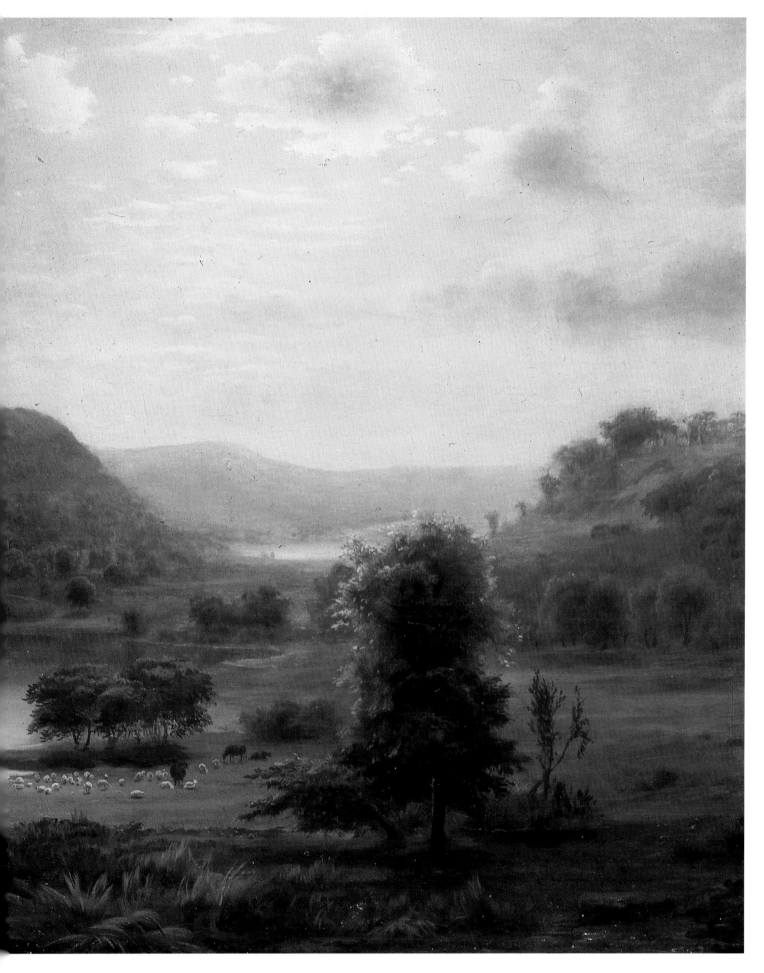

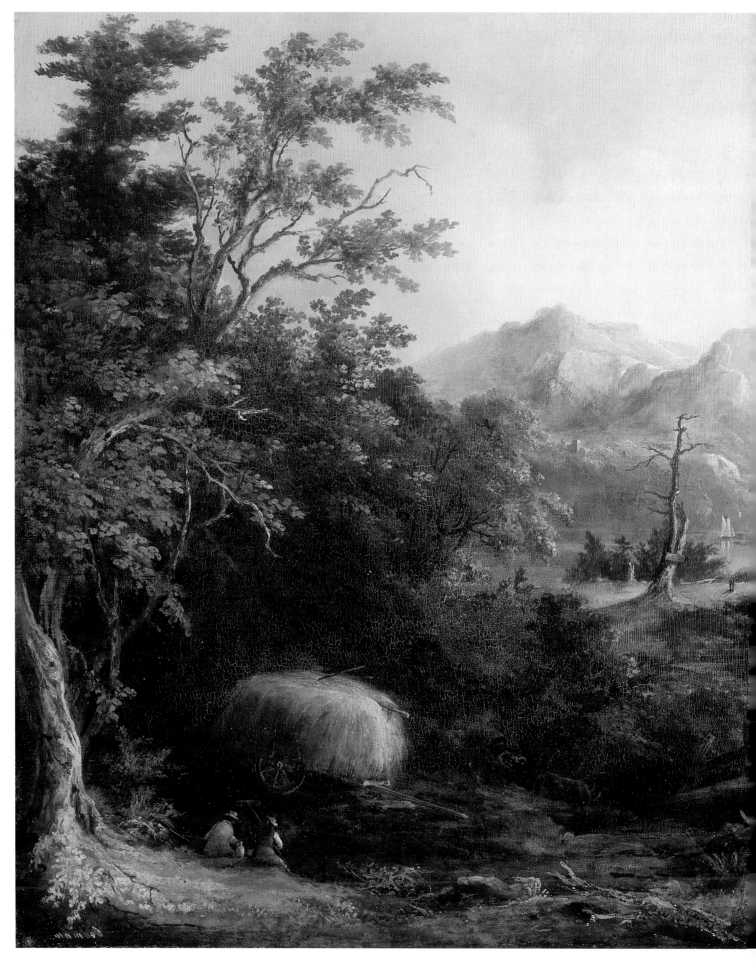

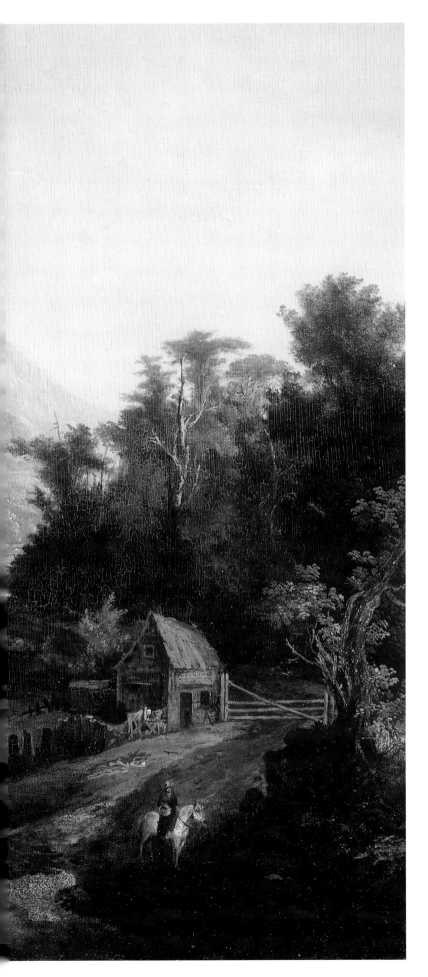

Pages 24–25

PLATE 12

Valley Pasture (1857)

Robert Scott Duncanson (1821–1872)

Oil on canvas, 32¼ x 48 inches (81.9 x 121.9cm)

(Courtesy National Museum of American Art)

PLATE 13 left

Landscape with Farm and Mountains
(1832)

Charles Codman (1800–1842)

Oil on canvas, 21 x 26 inches (53.3 x 66cm)

(Courtesy National Museum of American Art)

free in both brushstroke and colour and directly emotional in content. It expressed expansive sentiment rather than controlled intellectualism. It is not surprising that it attracted the young painters in a new and exciting country.

Since the Hudson River painters are mainly devoted to landscape, it is important to recognize the significance of J.M.W. Turner in the Romantic movement and as an influence on many of its devotees. It is not without interest that John Ruskin initially wrote his five-volume survey of painting, *Modern Painters*, in order to demonstrate the supremacy of Turner over all his contemporaries and most of his predecessors. Turner was the greatest figure of the Romantic painting movement and his exploration of light, atmosphere and colour is recognized as having been an essential influence in the development of Impressionism later on. He also directly influenced the Hudson River painters.

While looking at the American natural scene, as Cole later wrote in his 'Essay on American Scenery': '...the most distinctive, and perhaps the most impressive characteristic of American scenery is its wildness,' and adding, ' ...it is the most distinctive, because in civilized Europe the primitive features of scenery have long since been destroyed or modified.' This observation is important because, for the young American nation, breaking free of the stable conservative culture inherited from Europe, the vastness, grandeur and scale of American landscape, the great mountains and wide tracts of water betokened a new and expansive life to be discovered by the venturesome. From this, which is found first in the delights of the Hudson River, the notion was expanded throughout the whole wide territories. Where this is found in what might be called

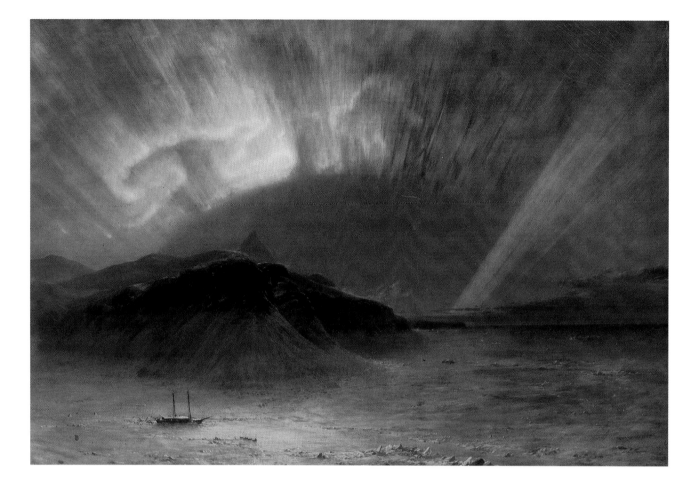

'romantic exaggeration', both mystical and practical, the Hudson River spirit is imbedded and the catchment area of associated artists is wide and undefinable. For these reasons – and bearing in mind the need for selection within the confines of a book which is not a catalogue – the choice has been made with no locational boundaries but within the widest limits that seem justified.

What also might be noted in respect of Cole's observations quoted above is an identification with European history and art. Most of the Hudson River painters travelled and studied in Europe and some painted subjects from European history or mythology, including Cole himself, as well as European scenes in the same romantic atmosphere as invests their American paintings. In disparaging the effete, ingrown character of European culture they were extolling the adventurous aspirations of their own young nation.

THE FOUNDING OF THE HUDSON RIVER SCHOOL: THE ORIGINS

The earliest course of American professional painting and sculpture had essentially derived its authority from European examples. Indeed, the connection with Europe was paramount since many, if not most of the painters were born

and received their training there, often making return visits to their countries of birth. Benjamin West, born of a Quaker family in Pennsylvania, was the first native-born American painter to move to Europe, first visiting Italy at the age of 22 and, on the death of Sir Joshua Reynolds, the founder President of the Royal Academy in London, becoming its second President. He represents the 18th century's connection and the artistic influence of European culture upon the developing separate American civilization.

By the 1830s, however, much had changed. American consciousness of itself resulted in an interest in its own qualities, opportunities and character and a diminution of the traditional attachment to Europe. During the decade, John James Audubon completed his great publication, *Birds of America*, George Catlin spent eight years studying the native American tribes, Alexis de Tocqueville published his volumes on *Democracy in America* in 1835 and in 1834 William Dunlap published a highly significant work, *History of the Rise and Progress of the Arts of Design in the United States*. All these developments indicate that American focus on its own achievements and potential had begun. When, in 1835, Thomas Cole published his 'Essay on American Scenery', already quoted above, following it in 1836 with his *Course of Empire*, a programme identifying the American people with

PLATE 14 opposite
Aurora Borealis (1865)
Frederic Edwin Church (1826–1900)
Oil on canvas, 56 x 83½ inches (142.3 x 212.2cm)
(Courtesy National Museum of American Art)

PLATE 15 below
Scene on the Hudson (Rip Van Winkle)
(1845)
James Hamilton
Oil on canvas, 38 x 57⅛ inches (96.6 x 145.1cm)
(Courtesy National Museum of American Art)

their landscape and its infinite variety, it was consciously initiated. In turn, this consciousness inspired a perception that a moral message could be drawn from the characteristics of nature itself while the role and authority of the American nation could be identified through a responsive reverence for it vastness and variety. Thus the landscape painter acquired a messianic reputation and his profession became something of a religious mission.

In their writings, both Dunlap and Cole were articulating a desire to define a national consciousness and the variety of nature and the natural order elevated to a moral belief was linked with American history, so that landscape painting became the source, previously confined to history painting, of moral imperatives and cultural standards. It achieved a didactic authority in American society. The result was that, rather than only representing the multitude of visual aspects of nature, from weather to geology, for the pleasure of observing and depicting them, the artists were invested with a duty, through nature and natural forces, to illustrate higher spiritual values.

Initially it was the group of painters that worked in the Hudson River valley and further into the Adirondacks, the Catskills and the White Mountains that looked for subjects that would express this elevated intention. From this location

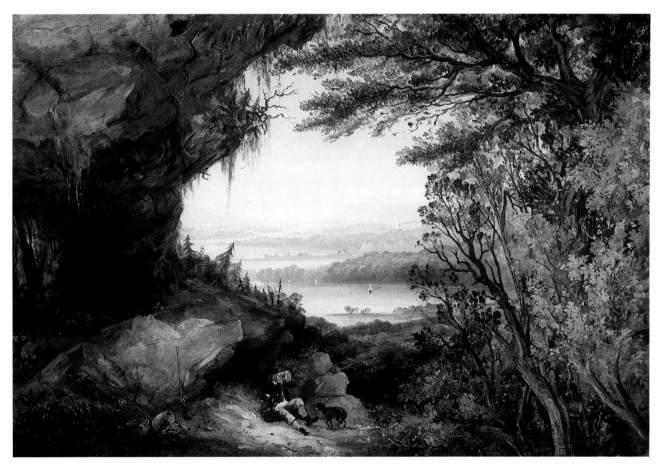

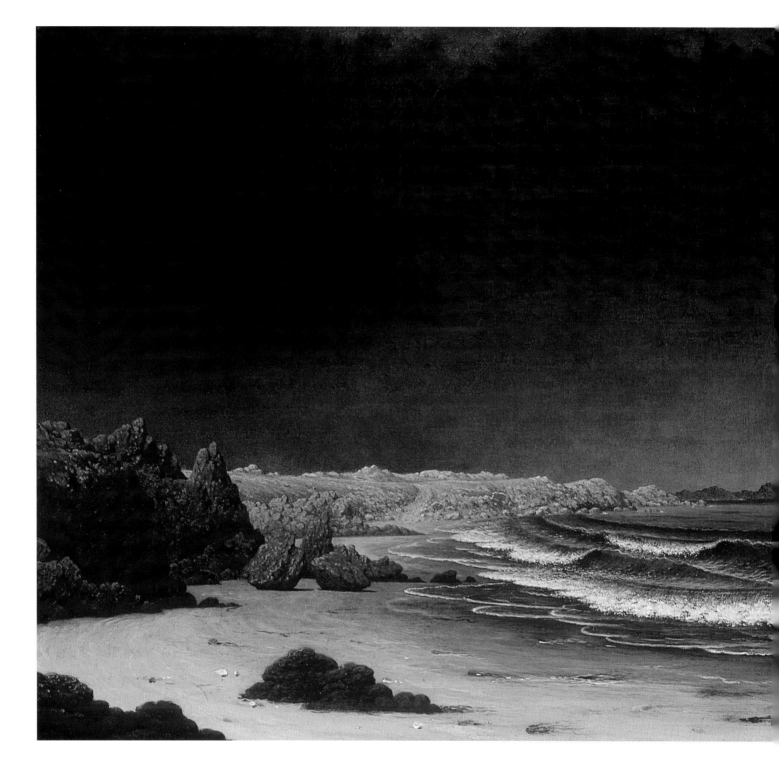

the spirit spread its wider net and during the subsequent decades there were bursts of zealous spiritual romanticism which may properly be closely or partially identified with the Hudson River School's wide remit, wherever they were located within the expanding United States.

Considered in retrospect, it appears to be more the spiritual overtone of these painters' work than their creative or imaginative nature that makes them of considerable interest. In Europe, as is well known, great changes occurred during the century and by its end the seeds of a modern art had been forged which hardly impinged on American consciousness until the Armory Show in New York in 1913. The Hudson River painters were a powerful force (one of many it must be admitted) in establishing a sense of national well-being and emotional yearning for social identity in the middle years of the century but did not contribute artistically to the great changes that were to occur later. For this reason, although important in the development of the American psyche, their work remains an interesting and sometimes fascinating and informative part of the Romantic movement.

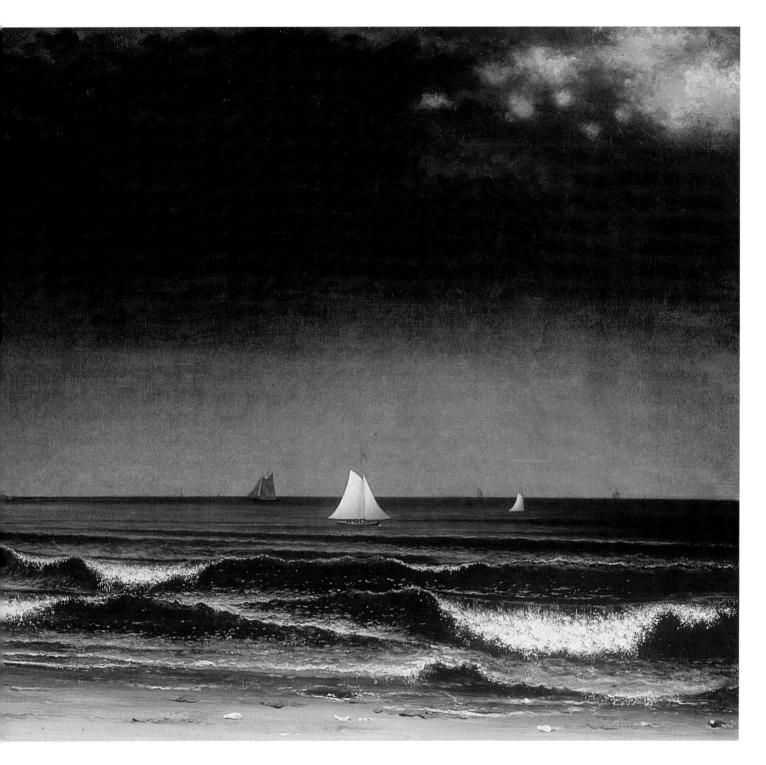

Nevertheless, in terms of the development of what might be called an indigenous American art form, the romanticism of the Hudson River painters was of a character that differed markedly from that of its contemporaries in Europe and contributed in a wider sense to the understanding of the limits and potential to be found in the term Romantic. Theirs was a constructed, induced romanticism, expressed with great observational care and controlled emotional content. The Hudson River paintings, whether actually of the Hudson area or more widely ranging

PLATE 16

Approaching Storm: Beach near Newport (c.1860)

Martin Johnson Heade (1819–1904)

Oil on canvas, 28 x 58³/₈ inches (71.1 x 148.3cm)

(Courtesy Museum of Fine Arts, Boston: Gift of Mrs Maxim Karolik for the M. and M. Karolik Collection of American Paintings, 1815–1865)

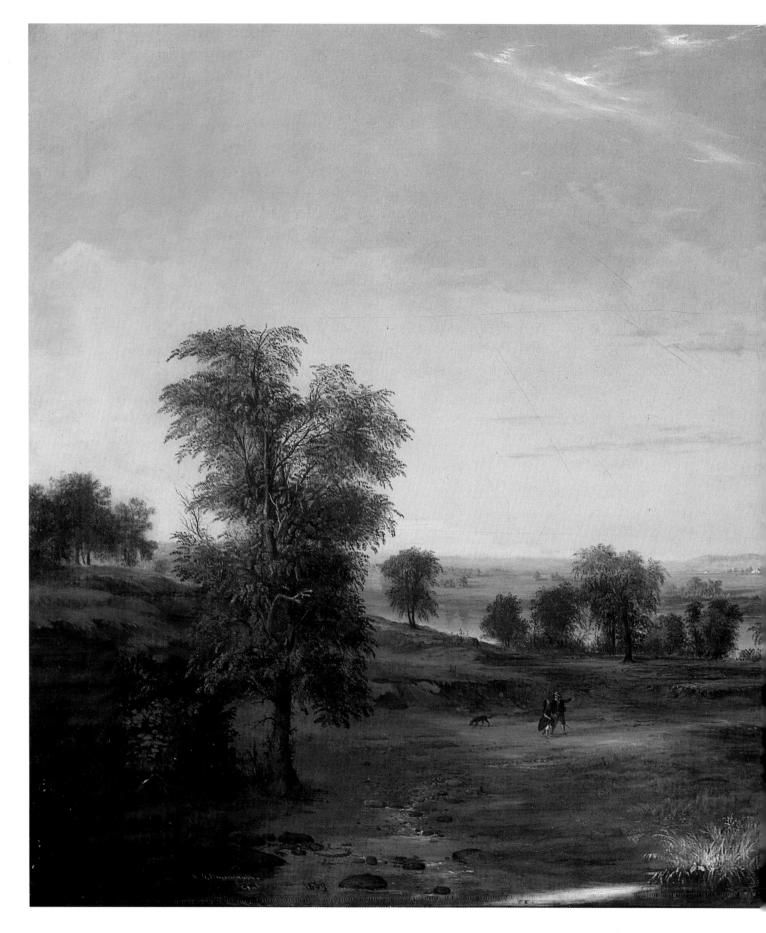

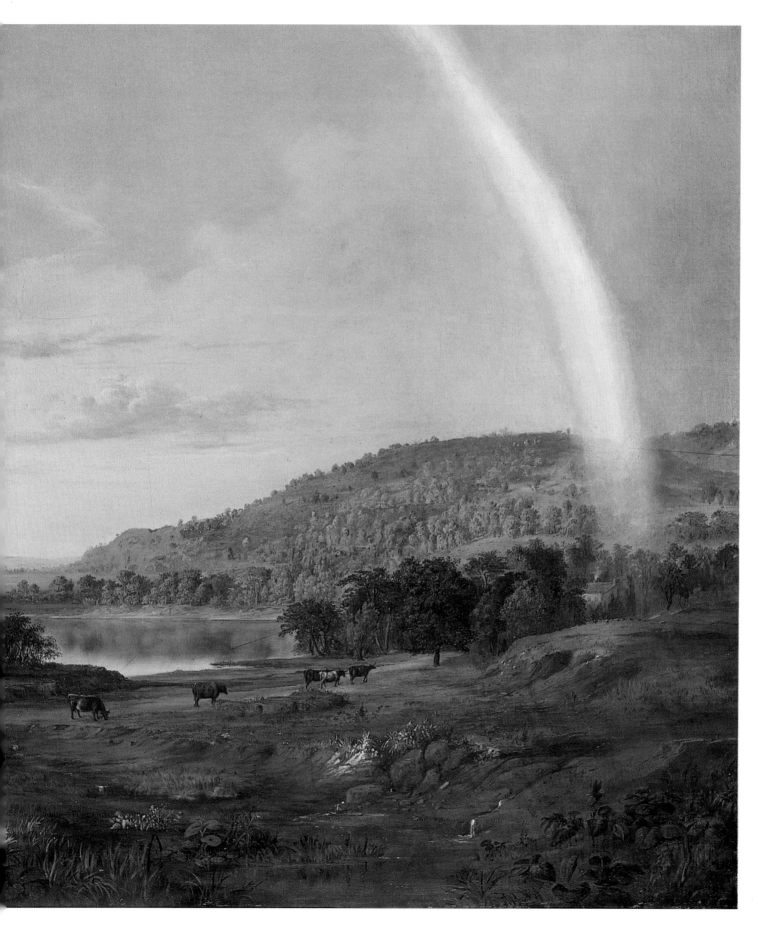

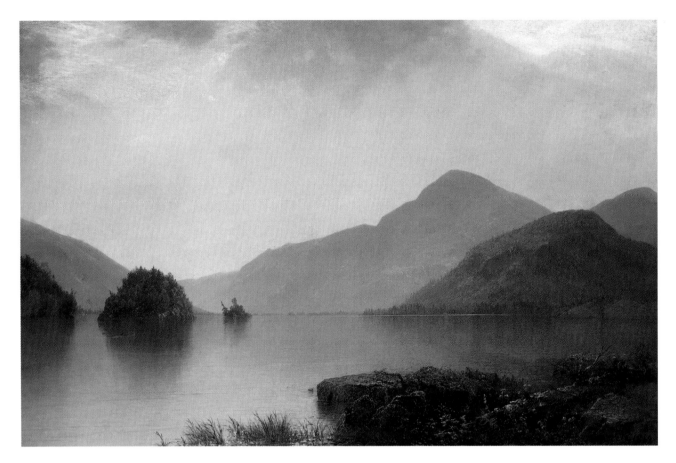

through to the Rockies, show a self-conscious awareness of a responsibility not only to portray the subject with great technical care but further to establish the emotional limits with equal diligence. Although the paintings have a strong appeal to the visual element in their appreciation, guided there by a tender clarity, they also write the moral message of God in nature, awesome and remote, in equally clear pictorial language.

THE ARTISTS

The artists considered below are mainly those illustrated in this short survey but where others are close in style and character to these limited few they will be mentioned by name but without biographical details.

THOMAS DOUGHTY (1793–1856)

Doughty began as a successful leather dealer in Philadelphia and painted as a hobby. As he had sold a few of his paintings, mainly topographical views of large country estates, he was more interested in becoming a professional painter so that by the age of 27 he abandoned his business and began, although self-taught, a successful landscape painting career. In 1822 he held his first exhibition at the Pennsylvania Academy of Fine Arts, Philadelphia. Like many of his contemporaries he retained a nostalgia for a Europe he

Pages 32–33
PLATE 17
Landscape with Rainbow (1859)
Robert Scott Duncanson (1821–1872)
Oil on canvas, 30^{1}/$_{8}$ x 52^{1}/$_{4}$ inches (76.5 x 132.7cm)
(Courtesy National Museum of American Art)

PLATE 18 above
Lake George (1869)
John Frederick Kensett (1816–1872)
Oil on canvas, 44^{1}/$_{8}$ x 66^{3}/$_{8}$ inches (112 x 168.5cm)
(Courtesy The Metropolitan Museum of Art: Bequest of Maria de Witt Jesup, 1915)

PLATE 19 opposite
The Birches of the Catskills (c.1875)
Thomas Worthington Whittredge (1820–1910)
Oil on canvas, 13 x 7^{3}/$_{4}$ inches (33.5 x 19.8cm)
(Courtesy National Museum of American Art)

Pages 36–37
PLATE 20
The Course of Empire: Consummation (c.1836)
Thomas Cole (1801–1848)
Oil on canvas
(Courtesy Collection of The New-York Historical Society)

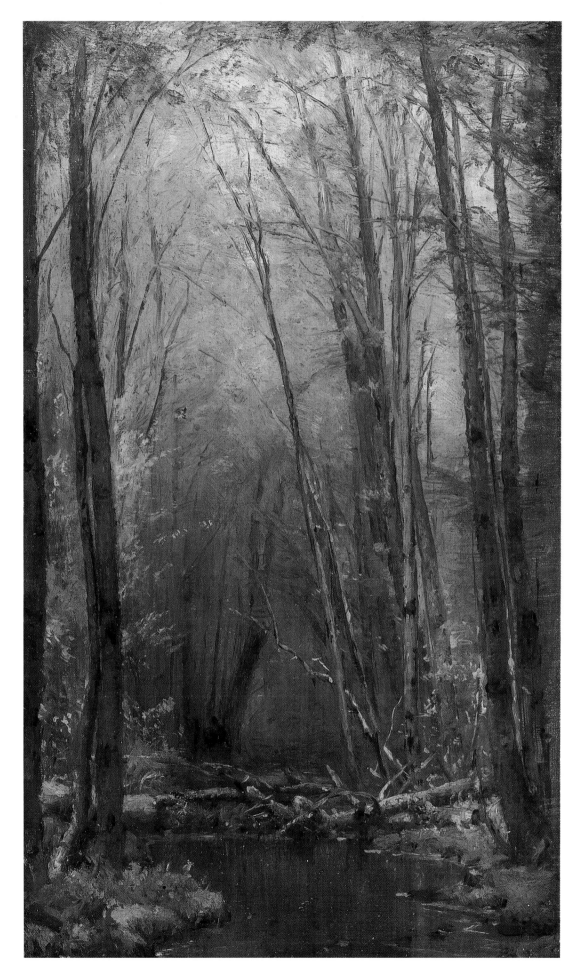

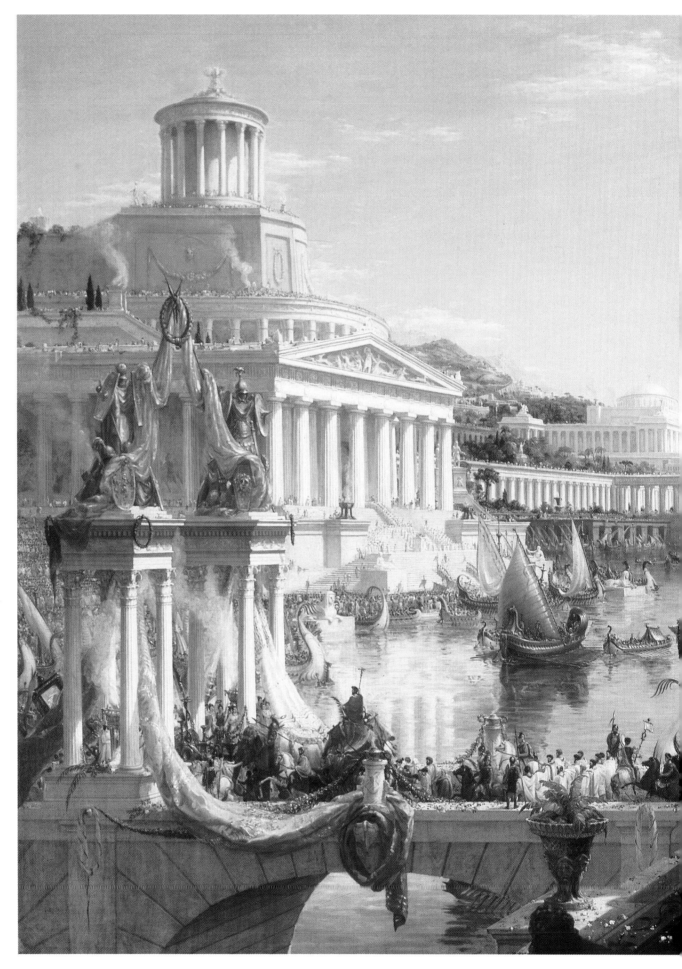

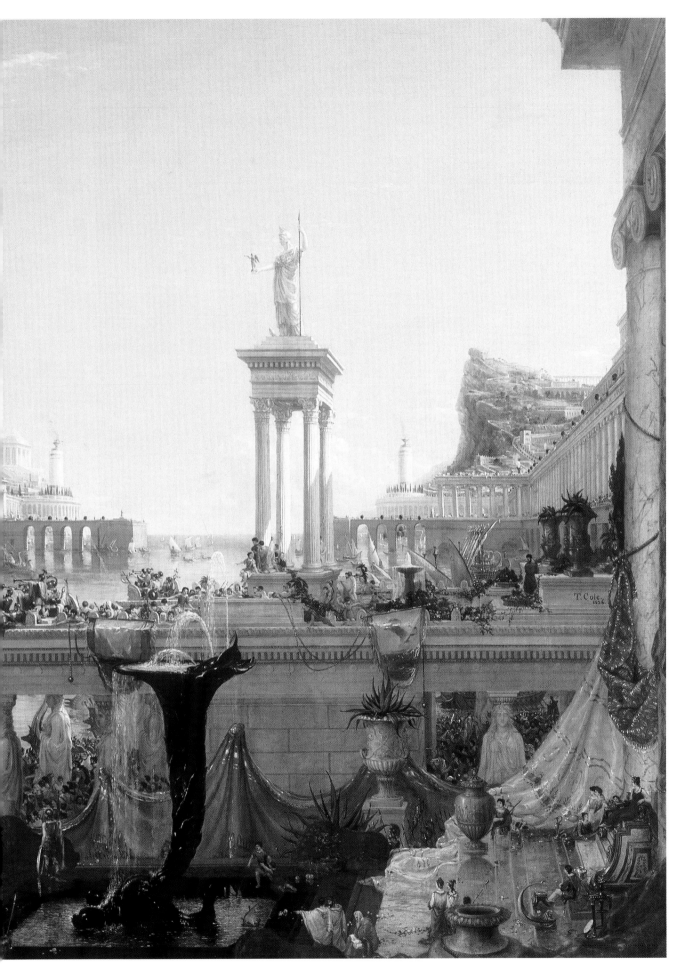

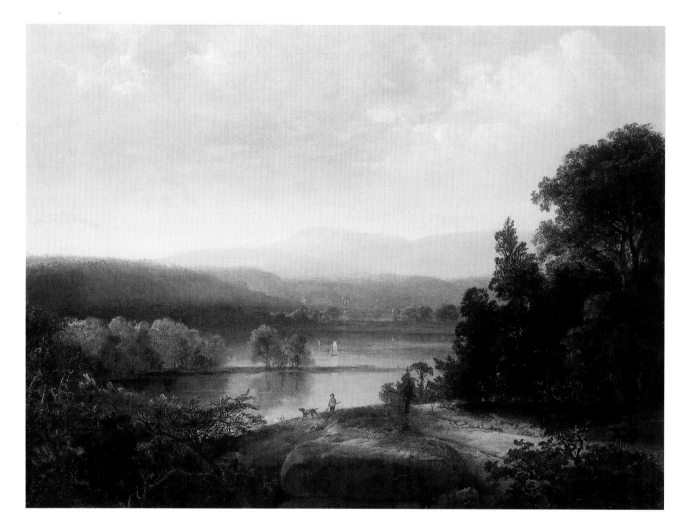

had never known and, also like them, yearned for a personal experience which later resulted in two visits, the first to England (1837), the second to England, Ireland and France (1845). He was the earliest born of what was to become the Hudson River School and his influence was important. His visits to Europe were of significance to his painting, particularly the influence of the Dutch 17th-century landscapists, to the extent that one of his painting is titled *Landscape after Ruisdael* (1846). Jacob van Ruisdael (1628/9–1682) was the most powerful of the Dutch landscapists with a particular interest in the effects of weather on dramatic and romantic locations reflecting the majesty of nature which, as noted above, was to become a dominant feature of the School's work.

Another influence, widespread amongst Hudson River artists, was the 17th-century French painter Claude Lorraine. Claude (1600–82) was a contemporary of Nicolas Poussin (1594–1665), both of whom were French and worked in Italy during the middle years of the 17th century. It is not surprising that Claude was favoured by Doughty and the Hudson River artists since; while Poussin represents the most intense intellectual rigour found in the classical

PLATE 21
River View with Hunters and Dogs
(c.1850)
Thomas Doughty (1793–1856)
Oil on canvas, 18½ x 25 inches (47.2 x 63.5cm)
(Courtesy National Museum of American Art)

PLATE 22 opposite
Cliffs of the Upper Colorado River, Wyoming Territory (1882)
Thomas Moran (1837–1926)
Oil on canvas, 16 x 24 inches (40.5 x 61cm)
(Courtesy National Museum of American Art)

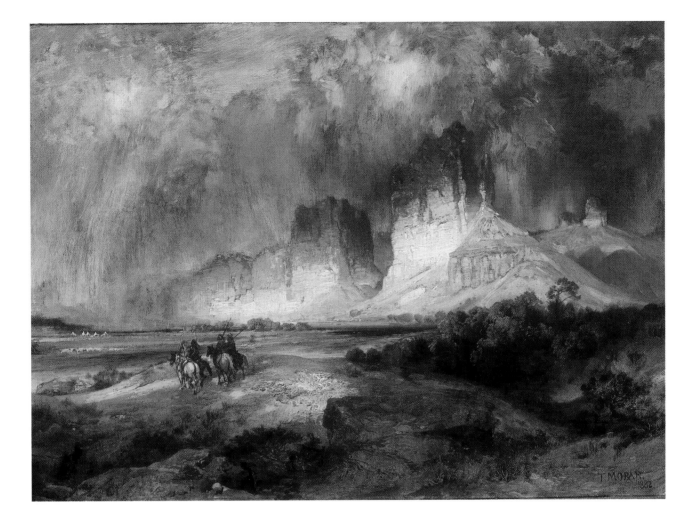

approach, Claude approaches nature with a romantic spirit that is much in parallel with that of Turner two centuries later. It is indicative that Turner requested in his will that his painting *Dido Building Carthage*, which he left to the nation, be hung between two of Claude's paintings, *The Seaport* and *The Mill* which has since been arranged.

In Doughty's *River View with Hunters and Dogs* (plate 21), the Claudian influence is apparent, as is its prototypical expression of the inherent Romanticism of the movement. Here Nature's overwhelming attraction seems to identify the vast creative power of the Almighty. The title of the work combines a sense of awe with childlike delight.

THOMAS COLE (1801–1848)

The recognized leader of the Hudson River School, Thomas Cole was born in Lancashire in England close to the Pennine range. His childhood was spent in the countryside and his visual imagination was directed towards design by his apprenticeship at the age of 14 to a designer of calico prints in the town of Chorley in Lancashire. Within a year he moved to Liverpool as an engraver's assistant. Through his youthful reading, he had dreamed of the grandeur of the American landscape, imagining it to be more majestic and awe-inspiring than his own English Pennines. So much so, that in 1818 he emigrated with his family to Philadelphia and while there produced a series of illustrations for Bunyan's *Holy War*. The family moved to Steubenville, Ohio in the following year and he taught painting and drawing at his sister's school, though only self-taught through commercial calligraphic experience. In 1823 he began his formal studies at the Pennsylvania Academy of Fine Arts, Philadelphia, after which he began to sell paintings and acquired some financial stability. Like Doughty, he travelled in Europe but between the years 1829–31, younger and some years earlier than Doughty. He also admired Claude and, additionally and significantly, Turner, then at the height of his fame, whom he met when in London in 1829. At this time he also met England's other great landscapist, John Constable. He was much moved by the ruins of the earlier civilizations of Europe, which offered an inspiring reminder of the long continuity of human endeavour and achievement.

On his return to America he found that his name was already famous and in 1836 he moved to his permanent home in Catskill, N.Y., near the Hudson and across the river from

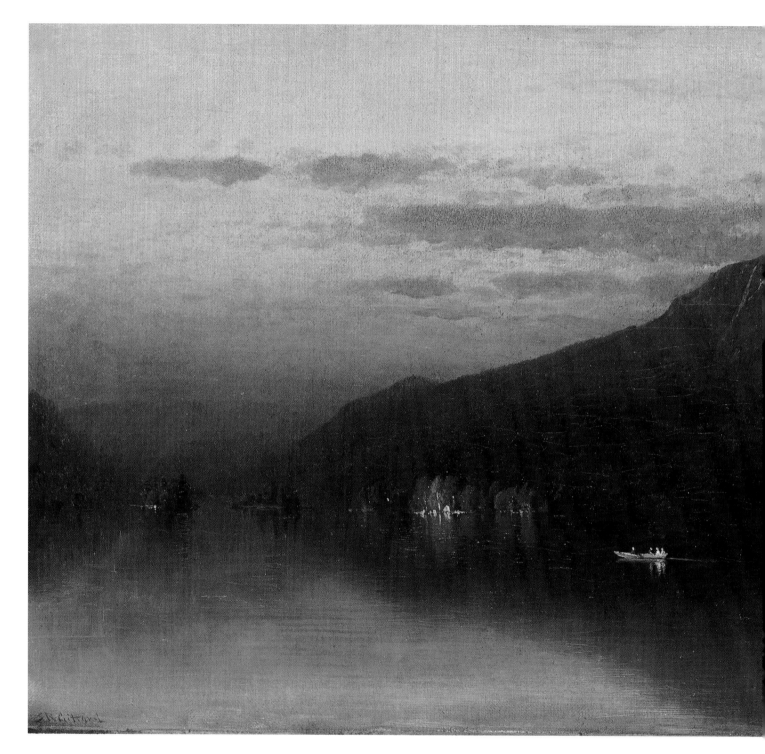

the town of Hudson. It was this location which remained, for the rest of his short life, as a permanent inspiration and, as a result of his fame, is the probable reason for the name adopted to identify the School. Landscape was his greatest love and the introduction of the human figure in his paintings, as they were with Claude, however seemingly important in the title of the work, are insignificant in his treatment of the subject. This is evidenced in his *Expulsion from the Garden of Eden* (1828) or *The Subsiding of the Waters of the Deluge* (plate 33). In these typical paintings, his meticulous draughtsmanship is allied to the romantic

interpretation of a biblical subject, while the influence of Turner can be seen in the storm clouds, immediately reminiscent of Turner's *Hannibal Crossing the Alps*, painted in 1812.

Cole's success as a painter and writer, which made him the acknowledged leader of the School, was closely related to his keen observation of the effects of nature and efforts to endow them with that sense of sublimity that introduces a mystical religious aura into his work and which appealed to his 19th-century audience. To today's observer it is perhaps his romanticism and love of nature

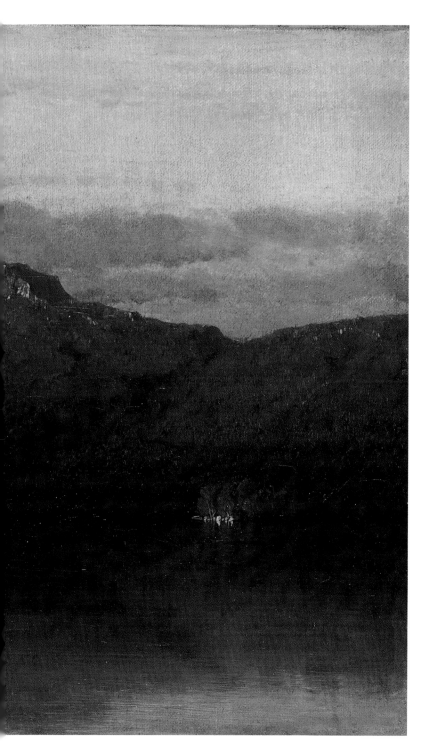

PLATE 23
Whiteface Mountain from Lake Placid
(1866)
Sanford Robinson Gifford (1823–1880)
Oil on canvas, $11^{2/3}$ x $19^{2/3}$ inches (29.5 x 49.8cm)
(Courtesy National Museum of American Art)

Pages 42–43
PLATE 24
Desert Rock Lighthouse, (1847)
Thomas Doughty (1793–1856)
Oil on canvas, 27 x 41 inches (68.6 x 104cm)
(Courtesy Collection of The Newark Museum: Gift of
Mrs Jennie E. Mead, 1939)

Raphaelite Brotherhood, romanticist and full of meticulous technique but essentially historicist and medievalist; of the contemporary German Nazarenes with similar preoccupations, while in France, Delacroix, Ingres, and other academics were engaged in the Salon dispute over Classicism and Romanticism. Perhaps the most interesting comparison between the landscapists of Europe and the Hudson painters is found in the work of the Barbizon School, who worked in France in and around the Forest of Fontainebleau during the 1830s. These painters, which included Rousseau, Díaz, Corot and Millet, painted their scenes with great affection and respect for nature, their images reflecting solitude and melancholy with a realist rationalist approach. On the other hand, the delight and awe in the American painting scene as it was developing, if seen in proper context (although initially inspired by Europe), has an engaging direct simplicity with deeply religious overtones.

ASHER BROWN DURAND (1796–1886)

Durand's best known work, *Kindred Spirits* (plate 1), was completed in 1849 and signals the transference of the School's leadership to him following Cole's death. Although he was five years older than Cole, he enjoyed a long life, dying at the age of 90. Cole and Durand had become friends and accompanied each other on sketching trips, including an extended excursion over the Adirondacks in 1837. *Kindred Spirits* has long been famous as the quintessential example of both the romantic spirit and of the nature of the Hudson River School philosophy.

It is appropriate here to indicate that the two figures, William Cullen Bryant (1794–1878), a romantic poet, and

that finds the greatest resonance. His highly original painting, *The Oxbow* (plate 27) has become a topographical symbol of American landscape treatment while his great series of paintings, *The Course of Empire* (see plate 20), are the first examples of the sense of monumentality found in European art and effectively expressed in American painting.

Cole's death in 1848, the Year of Revolutions in Europe, is a reminder of the essential difference and freshness of the Hudson River School from its European contemporaries. It was the year of the formation of the Pre-

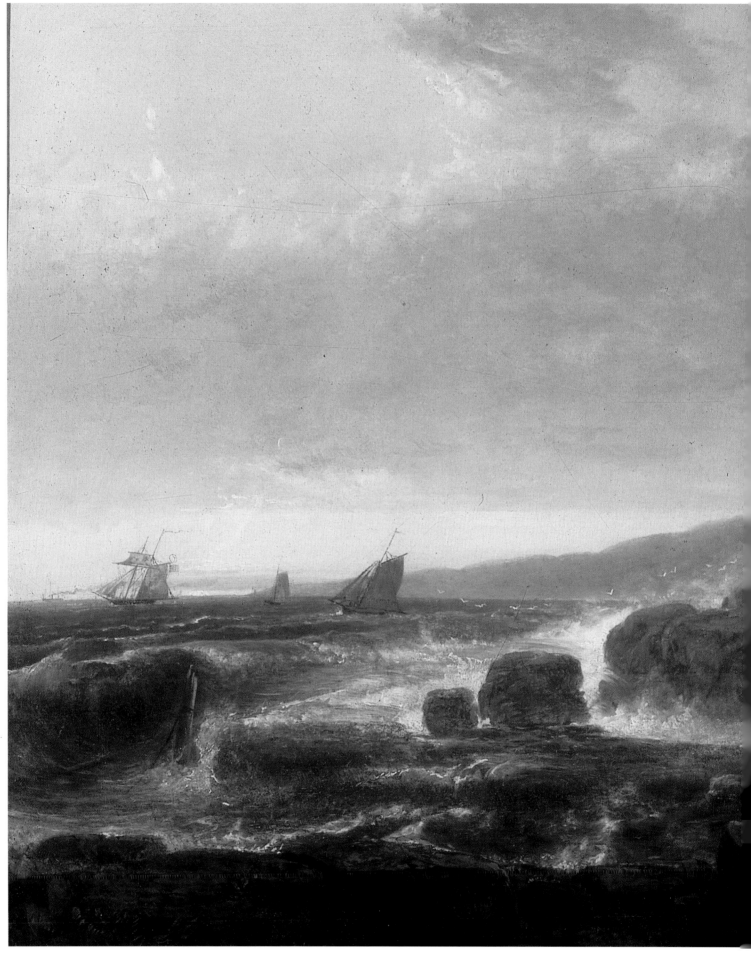

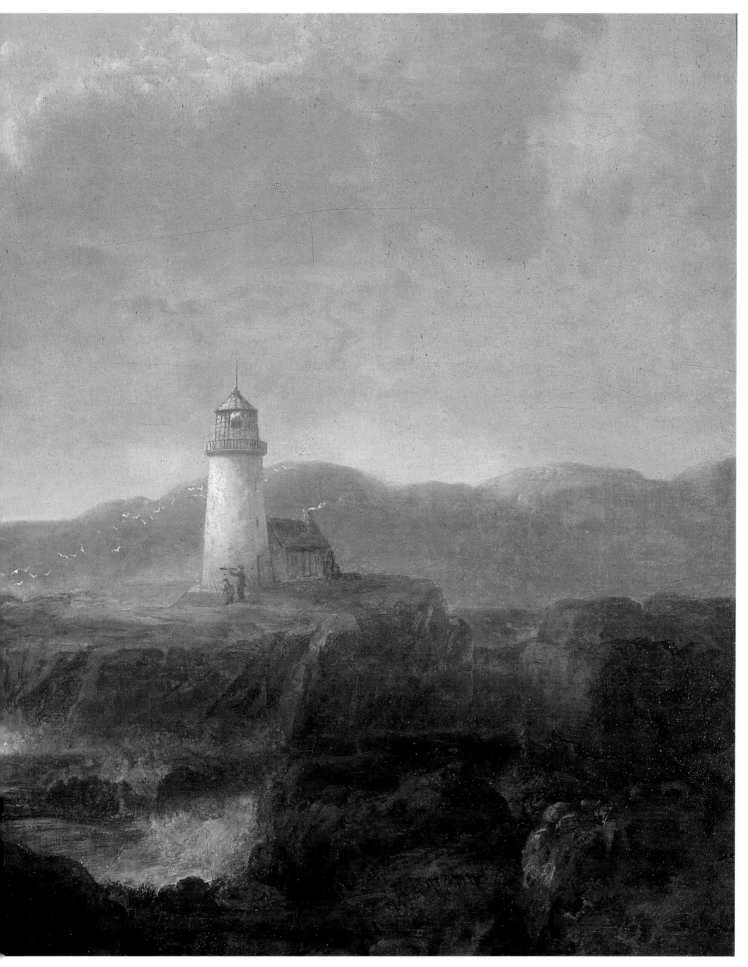

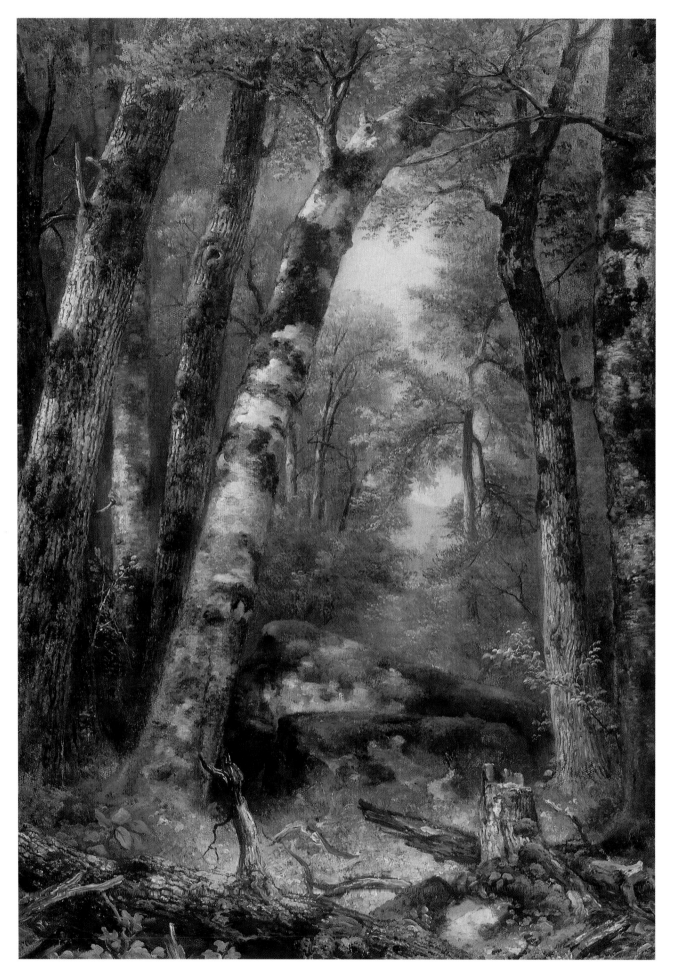

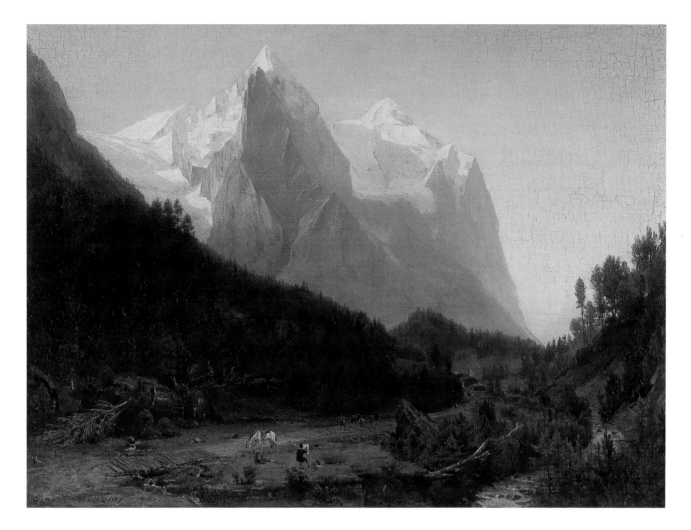

PLATE 25 opposite
Woodland Glen (c.1855)
Asher Brown Durand (1796–1886)
Oil on canvas, 24 x 18½ inches (61 x 47cm)
(Courtesy National Museum of American Art)

PLATE 26 above
The Wetterhorn (1858)
Thomas Worthington Whittredge
(1820–1910)
Oil on canvas, 39½ x 54 inches (100 x 137cm)
(Courtesy collection of The Newark Museum: Gift of Mr
and Mrs William Katzenbach, 1965)

Thomas Cole are surveying the scene as if discussing its
merits from a somewhat uninvolved Olympian perspective
– as if one or both owned not only the landscape but nature
itself and were in it but not a part of it. In this spirit, the
physical world can be used as a vehicle for spiritual
expression; in Durand's own words, it was 'fraught with
high and holy meaning, only surpassed by the light of
Revelation'. The title of the painting is interesting: does it
indicate that Bryant and Cole are kindred spirits or that
they are united in spiritual harmony with the landscape? Or
again, it may be that poetry and painting are kindred arts in
the expression of the human response to nature. At all
events it is a romantically suggestive title.

Durand was born in New Jersey and was trained as an
engraver with Peter Maverick from 1812 for five years,
after which time he became a partner for a further three
years. This experience instilled in Durand a linear sense of
pictorial construction, a sharp attention to detail and
compositional massing in tone. It also deflected his interest
towards painting and he made a number of portraits and
historical set pieces during the 1830s. Like many of his
contemporaries he made a grand tour of Europe (1840) and

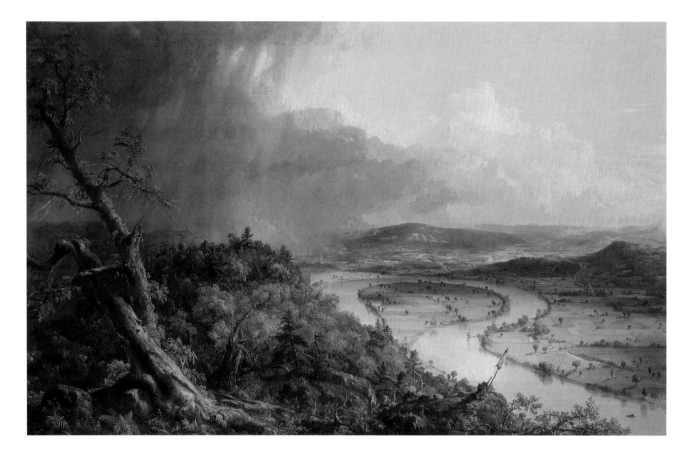

became President of the National Academy of Design in 1845. As his experience widened, his art developed into what became the essential character of the Hudson River School, more so in fact than Cole's art had ever been. His visit to Europe had broadened his vision, confirmed an admiration for such painters as Constable, Ingres, Delacroix and Rubens and most particularly for Claude. But the area in which he found his major inspiration was where the Catskill Mountains rise on the Hudson's west bank north of Kingston. The variety of the landscape, from the rich farmlands on the riverside to the broad calm river itself and the wild peaks with forested gorges, enabled Durand to explore the widest ranges of emotion and response. All this consolidated the title and became the established centre of the Hudson River School itself. One painter, who had visited Europe without any experience of the genre, on his return saw the works of Cole and Durand and was inspired to learn to paint again: 'I hid myself for months in the recesses of the Catskill.' Durand was aware of the potential importance of the School and sought 'an original school of art worthy to share the tribute of universal respect paid to our political advancement' – another revelation of the significance Durand attached to natural painting and an indication of the moral importance that was linked to both political and artistic activity.

PLATE 27 above
The Oxbow (1836)
Thomas Cole (1801–1848)
Oil on canvas, 51¹⁄₂ x 76 inches (130.8 x 193cm)
(Courtesy Collection of The Metropolitan Museum of Art, Gift of Mrs Russell Sage, 1908)

PLATE 28 opposite
Western Landscape (1869)
Albert Bierstadt (1830–1902)
Oil on canvas, 36¹⁄₄ x 54¹⁄₂ inches (92 x 137.8cm)
(Courtesy Collection of The Newark Museum, New Jersey)

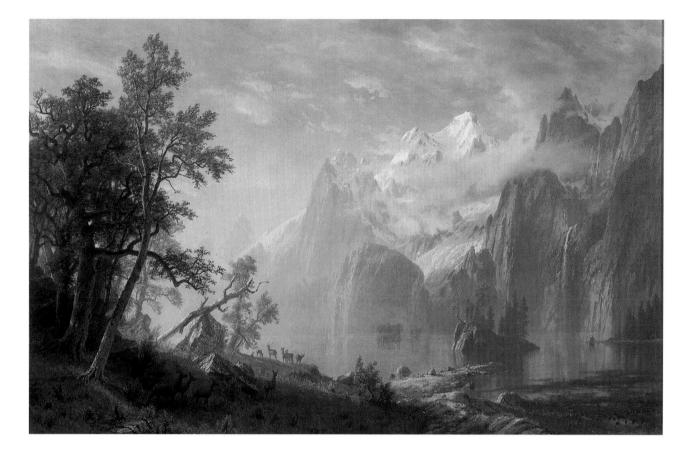

JOHN FREDERICK KENSETT (1816–1872)

Kensett was a significant figure in the development of the Hudson River School and was much admired by his contemporaries. Trained as an engraver, his work always displays a keen awareness of linear qualities and resulted in his considerable achievement as a draughtsman. He was born in Connecticut and acquired his engraving skills from his father, while his painting education came from his uncle in New York. In 1840 he began an extended visit to Europe, accompanied by Asher Durand and John Casilear, during which time he spent periods in Italy, France, Germany and England. While in Europe, he determined on painting as a career and on his return quickly achieved public success and recognition. He was one of the founders of the Metropolitan Museum of Art in New York and in his relatively short life as a painter exhibited widely in America and Europe and established a highly regarded cultural recognition in New York. He was one of the leaders of what has come to be regarded as the second generation of Hudson River painters and at the early age of 56 his death marked the apogee of the School. His particular enthusiasm was for the quiet and tranquillity to be found in the inshore bays and coves of New England and his paintings reflect the calm light of peaceful scenes – the very opposite of his contemporary Martin Johnson Heade's menacing stormy sea scenes (see plate 16).

ALBERT BIERSTADT (1830–1902)

Born in Solingen, Germany, Bierstadt's family moved to New Bedford, Massachusetts when he was two years old and where he was raised. His father was a barrel maker and had considerable reservations concerning his son's wish to become a painter instead of following a more 'practical' career. It was quickly apparent that he had a precocious natural talent and at the age of 20, without formal training, he had his first show in Boston. Soon after, he went to Düsseldorf, Germany where he studied under Karl Lessing, an engraver and painter whose long career mainly as a history painter also included a number of heroic naturalist landscapes. Bierstadt returned to America in 1857 and two years later joined a government survey expedition under Colonel Frederick Lander to plot an overland wagon route to the far West. The scenery en route made a deep impression on him and the many sketches he made provided him with most of the information for the many studio landscape paintings he later constructed. Fascinated by the grandeur and atmosphere of the Rockies and the far Western landscape he returned there in 1863 and again in 1871–73. In this wild and dangerous land he suffered for his passionate curiosity and was once almost killed by Indians and on another occasion nearly starved to death through his devotion to the solitary sketches he liked to make in isolated

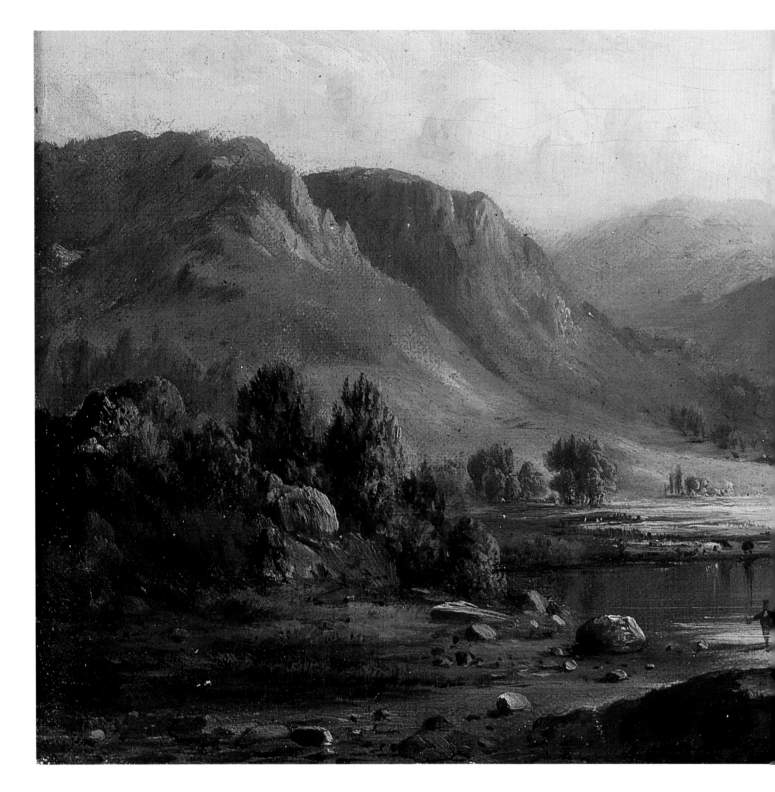

PLATE 29 detail
Loch Long, 1867
Robert Scott Duncanson (1821–1872)
Oil on canvas, 7 x 12 inches (17.7 x 30.3cm)
(Courtesy National Museum of American Art,
Washington, D.C.)

mountainous and tree-covered locations.

Although always identified with the Hudson River
School, his later subjects were taken from as far west as the
Rocky Mountains and even beyond. The melodramatic
Western landscape studio works which he painted on his
return, although finicky in detail, were conceived on a large
and heroic scale as befitted the vast terrain through which he
passed. (His *Rocky Mountains*, now in the Metropolitan
Museum, New York, measures 10ft/3m across.) He was a

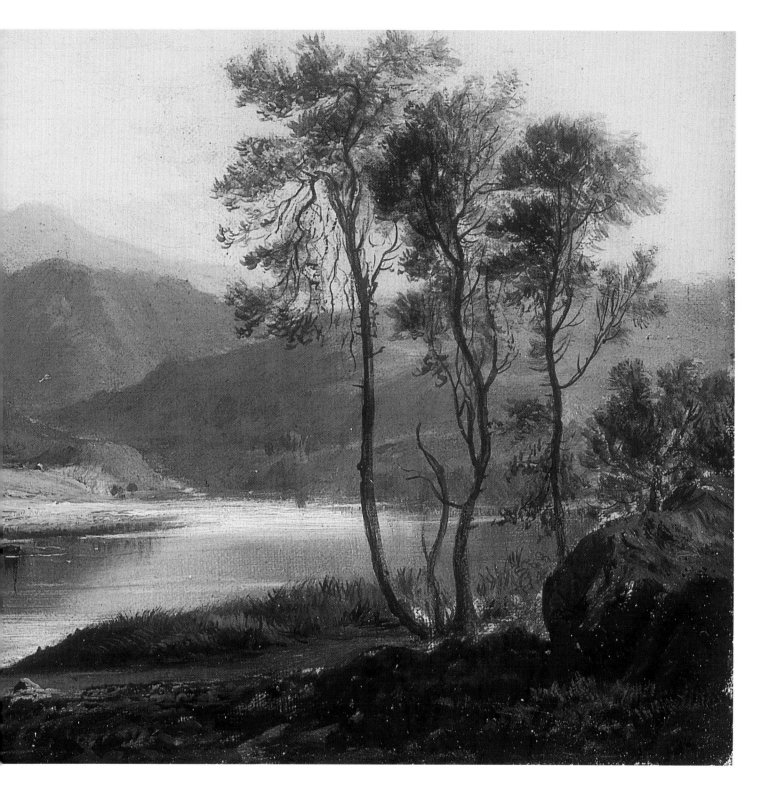

great success and at Irvington, New York State, he built a great mansion, Malkasten, overlooking the Hudson River. Its destruction by fire in 1882 marked the decline of his reputation, and by the end of the century he was regarded as a relic of a bygone age.

In this century, the strength of his imagination and the power of his imagery has been recognized and he is now established as one of the most powerful figures in the creation of the popular image of the American natural scene

although, as will readily be appreciated, his work is neither much in sympathy with the spirit of most Hudson River artists nor does it carry the sense of spiritual reverence characteristic of the School.

JASPER FRANCIS CROPSEY (1823–1900)

Born on Staten Island, New York, Cropsey wished to devote himself to painting but trained as an architect (he designed New York's Sixth Avenue elevated stations),

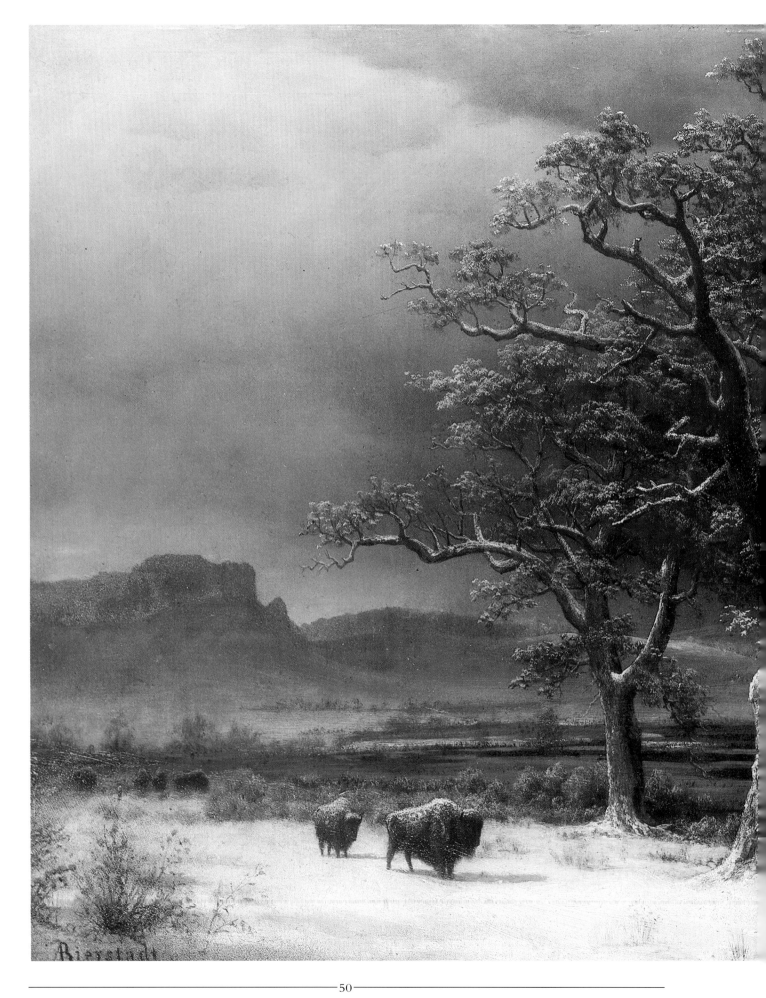

PLATE 30
Snow Scene with Buffaloes (c.1867–68)
Albert Bierstadt (1830–1902)
Oil on canvas
(Private Collection)

working in a New York architect's office for five years
before becoming a painter. He exhibited at the age of 20 in
the National Academy of Design. Like many of his peers he
visited Europe, firstly for three years from 1847–50 and
again from 1857–63. On his first visit to Rome in 1847 he
stayed, appropriately, in the studio formerly used by
Thomas Cole. His second visit, which lasted for seven years,
included a period in England during which time he studied
and was influenced by the Pre-Raphaelite painters and by
Constable and Turner. From the Pre-Raphaelites he
acquired a concern for minute detailed accuracy and from
Turner a passionate interest in the qualities of light and
atmosphere as part of personal pictorial expression. After his
first visit he soon began to achieve a success with his
romantic landscapes, sensitively drawn and often bathed in
autumnal sunlight of a somewhat 'chocolate box' character.

His painting *Starrucca Viaduct* (1865) reminds us that the
Hudson River painters lived in the age when the steam
engine, the 'iron horse', was an object of romance. It is an
image which endures in Western films, that of trains
crossing the wide expanses of the prairie and still has the
power to evoke nostalgia. It is also interesting to recall that
in Europe in the year that this work was executed, Manet's
painting *Olympia* was being exhibited in Paris and
Impressionism was at its initial stages. Five years later
Claude Monet, who gave Impressionism its name, painted
his *Train in the Country*, a view of a train crossing a viaduct.

ROBERT SCOTT DUNCANSON (1821–1872)
Duncanson was born in New York of mixed parentage, his
mother being a free Black and his father a Scottish-
Canadian. He grew up in Canada and probably moved to
Ohio when he was about 20 in 1841. Feelings generated by
the abolition of slavery were strong and life was often
difficult but, although almost entirely self-taught, he won a
number of notable portrait commissions as well as attracting
the attention of an important patron, Nicholas Longworth,
who commissioned murals from him.

He made two trips abroad in 1853 and 1863 which
appear to have stimulated a strong interest in landscapes. He

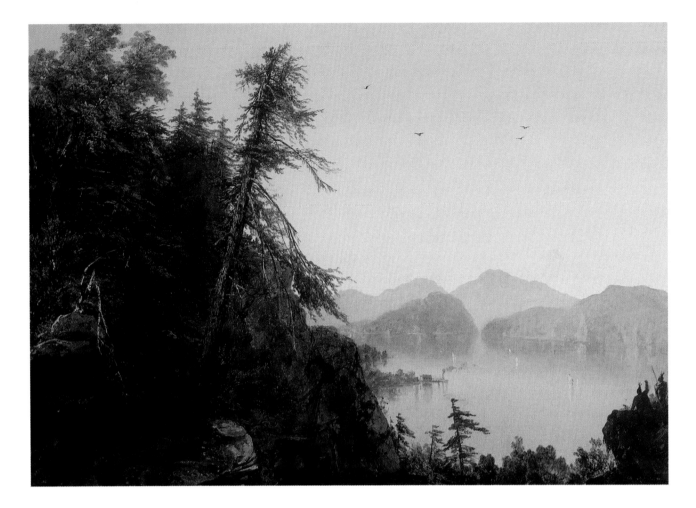

reached the height of his career at the age of 30 and his *Blue Hole, Flood Waters, Little Miami River*, painted in 1851 is a transitional work from the earlier transcendental to the later light-dominated work of the School. By the time he was 40 a newspaper reported that he 'enjoyed the enviable reputation of being the best landscape painter in the West'. Through his evident abilities and tenacity of purpose he travelled in Europe, moving in all levels of society at a time when this was almost unheard of, particularly in a person of dark complexion. His work is still admired for its technical and imaginative quality, his best known paintings being located in the area of Lake Superior.

THOMAS WORTHINGTON WHITTREDGE (1820–1910)

Bearing a name of such resonant grandeur it is not surprising that Whittredge achieved great success progressing from a humble environment in a frontier log cabin near Springfield, Ohio on the Little Miami River, close to where Duncanson also painted, to becoming President of the National Academy of Design. His father had been a sea captain in Massachusetts and Whittredge grew up surrounded by stories of the sea and the glories of

the New England landscape and this influence drew him later to paint scenes of the coast. Along the way he collected honours, in both America and Europe, and published his autobiography in 1905 at the age of 85. Largely self-taught, contrary to parental approval, and with only a background of house- and sign-painting as training, by the 1840s he was determined to become a landscape painter. He showed remarkable technical talent, a deep love of nature and a rare sensibility which resulted, after a long and successful career, in a fine body of work. Although his main interest lay in the Hudson River locality and the Catskill Mountains were his passion, like most of his contemporaries he was an inveterate traveller both in America and Europe. (In 1849 he embarked on a trip which lasted ten years, mainly in France and Belgium, during which time he was influenced by Corot and other Barbizon painters.) More critical to his development, however, was the time that he spent in Düsseldorf at the popular school run by Karl Lessing and others where a number of other American painters studied, including Caleb Bingham, Eastman Johnson, Albert Bierstadt and J.M. Hart. He was somewhat ambivalent in his views of the Düsseldorf experience and observed that 'many of

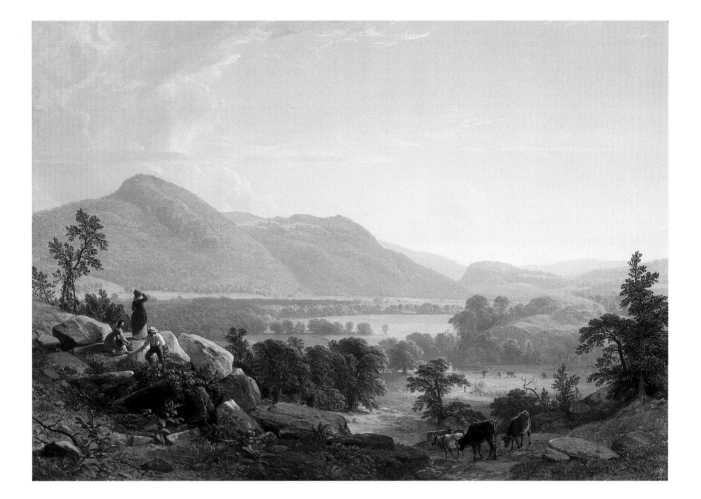

PLATE 31 opposite
Along the Hudson (1852)
John Frederick Kensett (1816–1872)
Oil on canvas, 18 x 24 inches (45.9 x 61cm)
(Courtesy National Museum of American Art)

PLATE 32 above
Dover Plain, Dutchess County, New York
(1848)
Asher Brown Durand (1796–1886)
Oil on canvas, 42¹/₂ x 60¹/₂ inches (107.9 x 153.7cm)
(Courtesy National Museum of American Art)

these works were in the hardest German style, colourless and with nothing to recommend them except their design'. Most influential, however, was his trip into Italy over the Alps which astonished and overawed him to such an extent as to lead him to remark 'I have been accustomed to measure grandeur, at the most, by the little hills of West Virginia'. It was his discovery of the effect of the sweeping view with horizontal emphasis that influenced his later work which is evident in his *Harvest Time: Summer in Farmington Valley* (plate 45), one of his last works which shows little diminution in his painting skills.

FREDERIC EDWIN CHURCH (1826–1900)

Church was born in Hartford, Connecticut of a well-off family with cultural associations which included contact with Thomas Cole who became Church's teacher and, in turn, Cole's first and only important pupil. Church became the leader of the later generation of Hudson River painters and could be described as the culminating master of the School. One of his most important early works, setting the scene for the later development of the Hudson river philosophy, was his *Niagara Falls* which, with its strong horizontal emphasis and a carefully selected viewpoint, gives a new and

PLATE 33 opposite
The Subsiding of the Waters of the Deluge
(1829)
Thomas Cole (1801–1848)
Oil on canvas, 35³/₄ x 47³/₄ (90.8 x 121.4cm)
(Courtesy National Museum of American Art)

Pages 56–57
PLATE 34
Landing of Columbus (c.1893)
Albert Bierstadt (1830–1902)
Oil on canvas, 72 x 121 inches (183 x 307.4cm)
(Courtesy Collection of The Newark Museum: Gift of Dr J.
Ackerman Coles, 1920)

dramatic insight into a subject which has been popular with
painters since early in the century. The painting also
contains the great symbol of hope, a rainbow, as the water
surges into the depths. The painting became much
celebrated in America and was publicly admired by Ruskin
– almost a holy sanction at that time. As well as painting in
the Hudson River and Catskill areas, Church travelled
extensively throughout Europe and the Middle East over a
period of years. He visited such widely different locations as
Mexico and Syria, painting his luminous and meticulous
landscapes. His dramatic depiction of the erupting Cotopaxi
is reproduced (plate 40) and Church describes it as follows:
'Cotopaxi is represented in continuous but not violent
eruption. The discharges of thick smoke occur in successive
but gradual jets ... so that the newly risen sun flares with
lurid fire through its thick volumes.' A successful painter, he
travelled in reasonable comfort with friends, official and
unofficial and, as one report reveals 'They ate off a snowy
tablecloth and [had] all the appointments of a good
table'. They were supported by 16 camels, 21 men and two
horses. (Note order of priority.)

SANFORD ROBINSON GIFFORD (1823–1880)
One of the features of most Hudson River paintings is the
evident fascination of their creators with the varied effect of
light in landscape, from dawn to dusk or at night. It was
perhaps the dominant motivation for Gifford's work and
with other late Hudson painters such as Church, Kensett
and Heade, he formed the group known, with justification,
as Luminists. Like so many of his contemporaries, including

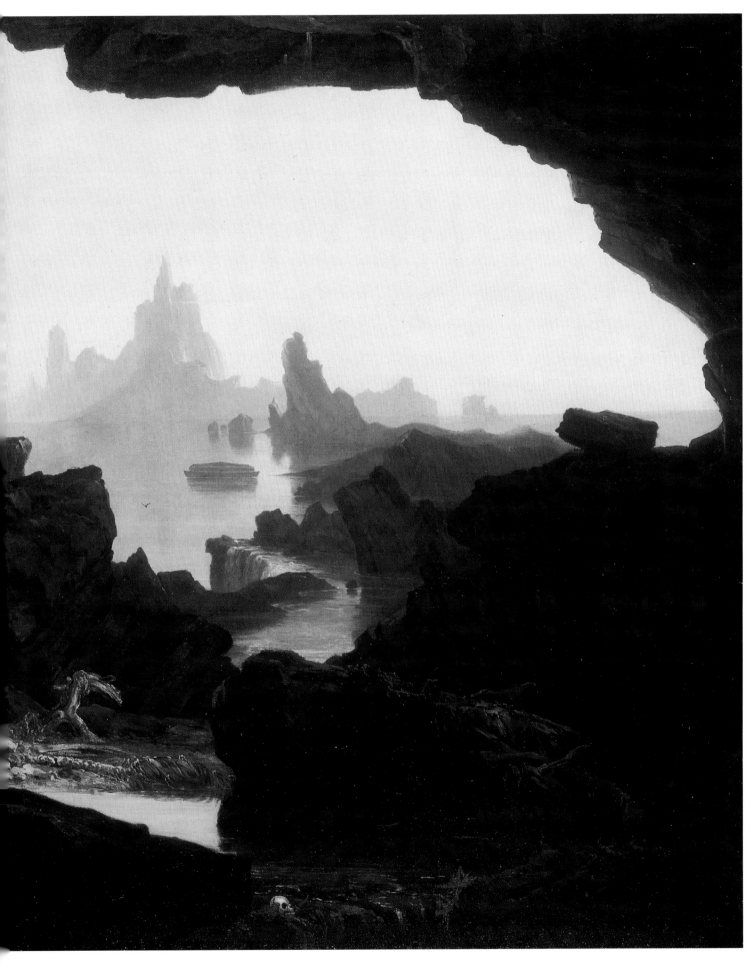

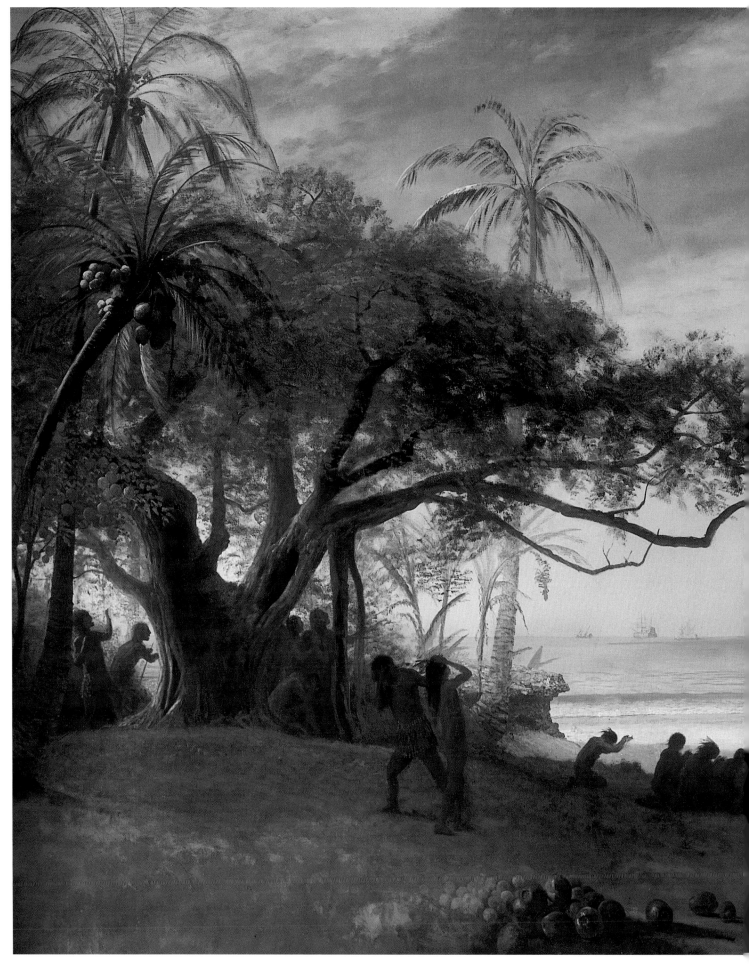

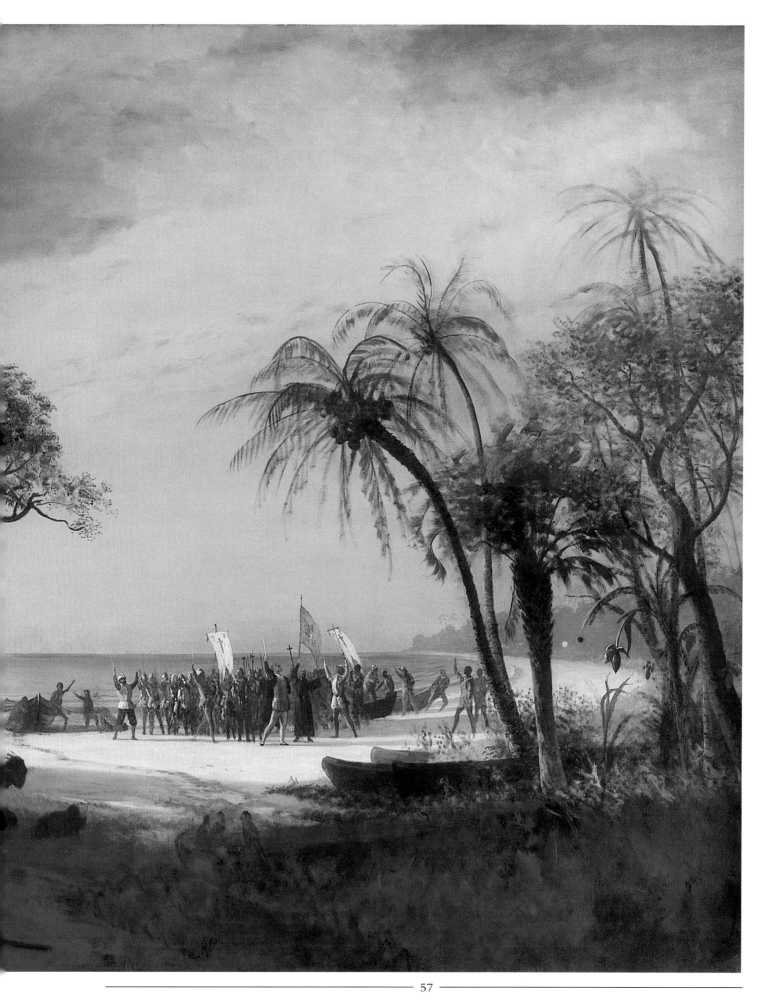

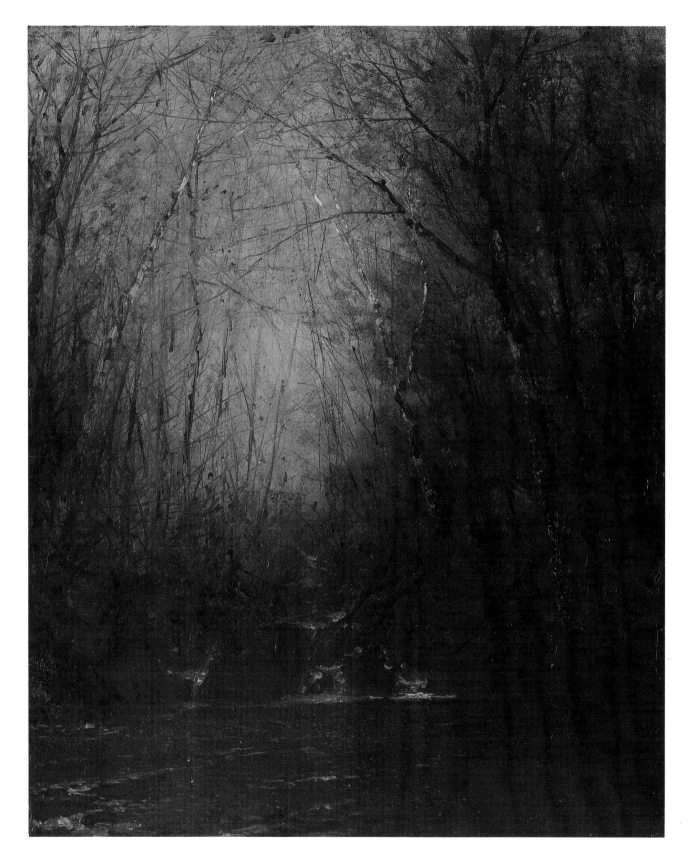

PLATE 35 above
Forest Interior with Stream (c.1860–70)
John Frederick Kensett (1816–1872)
Oil on canvas, 17³/₈ x 14¹/₂ inches (44.2 x 36.8cm)
(Courtesy National Museum of American Art)

PLATE 36 opposite
Waterfall on Mont-Morency (1864)
Robert Scott Duncanson (1821–1872)
Oil on canvas, 18 x 27³/₄ inches (45.7 x 70.6cm)
(Courtesy National Museum of American Art)

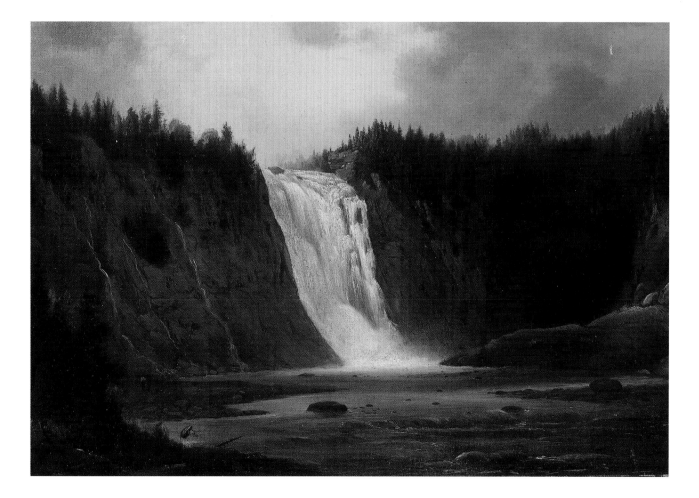

Cole, Gifford was influenced by and knew John Ruskin (1819–1900) whose reputation as an artistic guru was wide and authoritative. Not surprisingly, another influence was that of J.M.W. Turner, whose romantic painting and unique powers in the expression of light through colour is now universally admired and respected.

Gifford grew up in Hudson, New York, on the banks of the Hudson River and after two years at Brown University began studying painting. Inspired by a journey through the Catskill Mountains and the Berkshire Hills in Massachusetts, he decided to devote himself to landscape painting and after the American Art Union purchased some of his work his career success began. He made a two-year trip to Europe where he met Ruskin who gave him encouragement. Subsequently, he travelled widely across the United States, through Europe and even to Syria. Nevertheless, it was the Catskills that he loved best to paint and he was successful in this and much admired by his peers. He married at the age of 54 but only three years later contracted an illness which developed into pneumonia and he died in 1880. His paintings were characteristic of the Luminist group of painters whose works appeared to be suffused with a palpable light.

MARTIN JOHNSON HEADE (1819–1904)

Heade was the oldest and longest-lived member of the Luminists who provide an example of the difficulties in defining the limits of what might be called the Hudson River style. Cropsey, Kensett, Whittredge and Church, all included here, are usually accepted as part of the Hudson River School and it is sometimes suggested that the Luminists are merely a late expression of Hudson River painting. On the other hand, they appear to have had a quite distinct approach to the portrayal of light through colour and tone from the work of Cole and the early painters. It is of course not surprising that the Luminists had a strong admiration for the paintings of Turner. It is appropriate to mention the work of Frederick Law Olmsted (1822–1903) who would now be described as a landscape gardener but whose main work was the design of great urban parks including Central and Prospect Parks in New York, Golden Gate Park in San Francisco and the Back Bay development of Boston. These works were urban creations of the Hudson River ethos providing both spiritual and physical recreation for the public with Ruskin's moral imperative as their inspiration.

Heade was born in Lumberville, Pennsylvania and

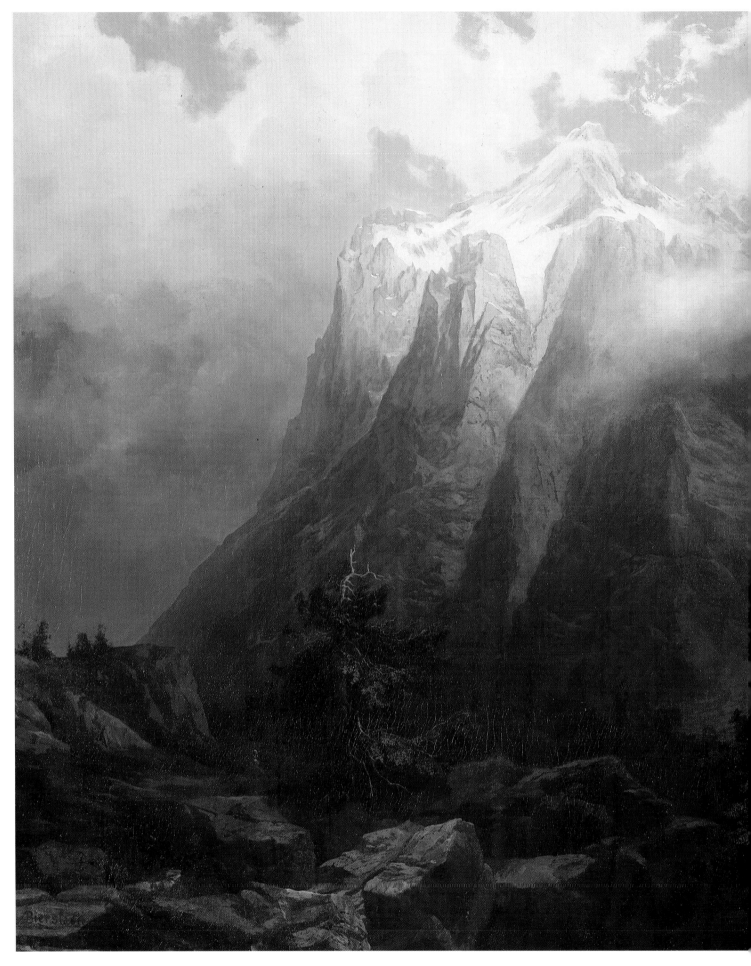

PLATE 37 opposite

The Wetterhorn, Switzerland

Albert Bierstadt (1830–1902)

Oil on canvas

(Private Collection)

Pages 62–63

PLATE 38

Pompeii (1871)

Robert Scott Duncanson (1821–1872)

Oil on canvas, 21 x 17 inches (53.3 x 43.2cm)

(Courtesy National Museum of American Art)

received some artistic instruction from Edward Hicks (1780–1849), whose powerful primitive style has gained him high regard. At the age of 19 he made a visit to Europe and ten years later, in the Year of Revolutions he made a second, this time visiting Rome. On his return he moved first to Chicago, then to St. Louis before returning to the east coast. These frequent locational disturbances are reflected in the variety of his subject matter as well as inducing in him a sense of wistful loneliness evident in many of his works. His paintings have affinities with those of both Whittredge and Kensett. In his work a dark expression of luminism can be seen in, for example, *Approaching Storm: Beach near Newport* (plate 16). He made further trips between 1863 and 1870, including one to Brazil, which resulted in a series of paintings of orchids and hummingbirds. After his marriage at the age of 64 he settled in Florida. In his later years he produced a number of flower studies (of cut sprays of giant magnolias) which carry curiously sensual overtones and are reminiscent of the paintings produced much later by Georgia O'Keeffe.

THOMAS MORAN (1837–1926)

Moran was born in Bolton, Lancashire, an industrial town near to where Thomas Cole had been born over 35 years earlier. He had been taken to America at the age of seven where he was apprenticed to a wood engraver and illustrator at the age of 16. In about 1862, Moran revisited England where he was inspired by the paintings of Turner, which remained a lifelong passion. He was a prolific painter but his grandiose romantic landscapes, while possessing some of the qualities of the best of the Hudson River genre, lacked the sensitivity of that of his peers. While

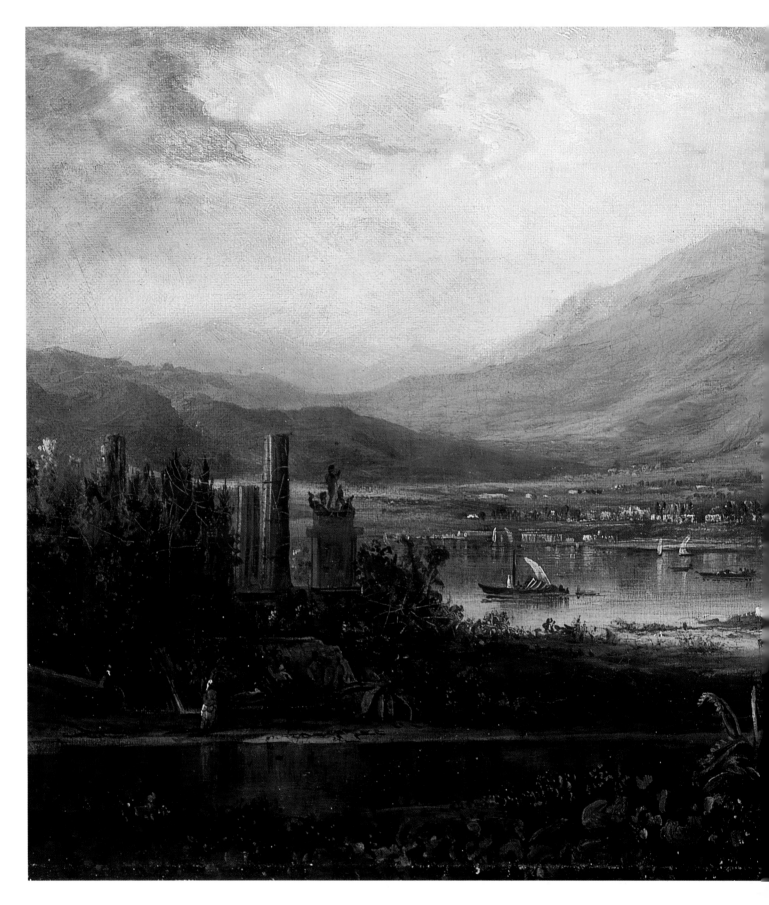

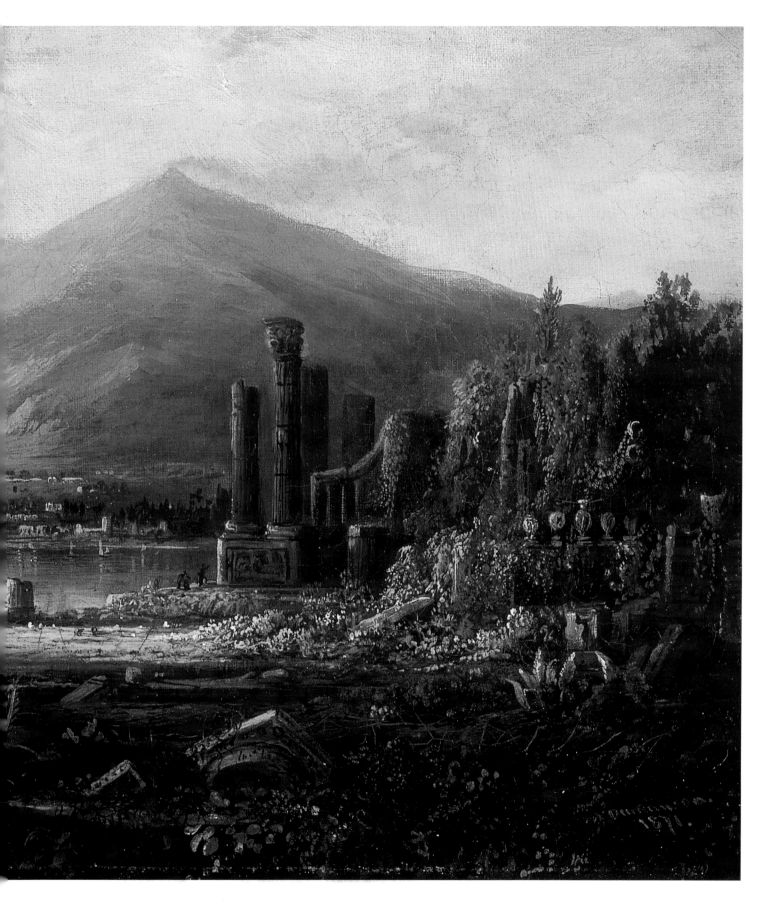

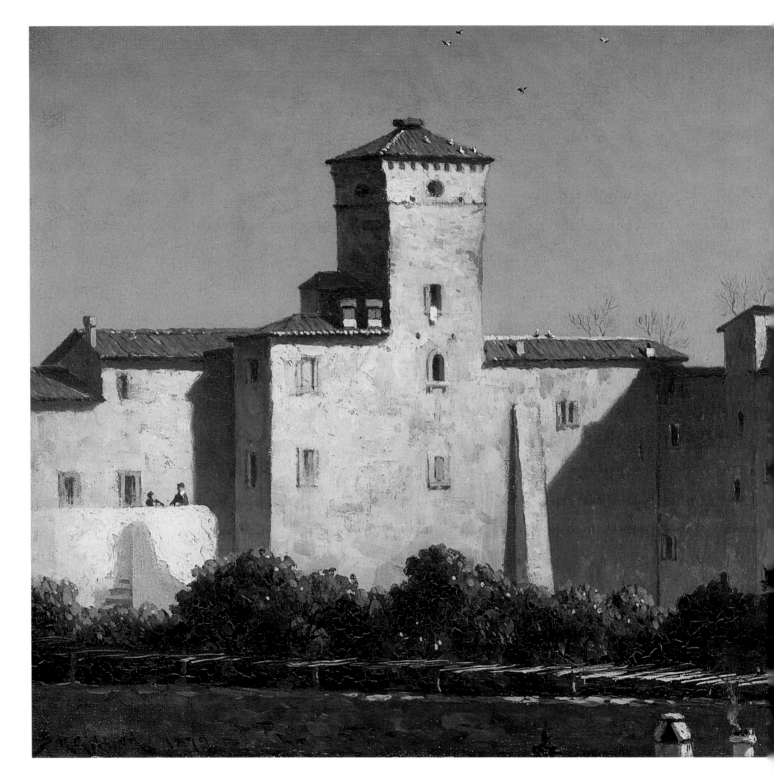

PLATE 39 above
Villa Malta, Rome (1879)
Sanford Robinson Gifford (1823–1880)
Oil on canvas, 13¼ x 27⅓ inches (33.6 x 69.5cm)
(Courtesy National Museum of American Art)

Pages 66–67
PLATE 40
Cotopaxi (1855)
Frederic Edwin Church (1826–1900)
Oil on canvas, 28 x 42 inches (71.1 x 106.8cm)
(Courtesy National Museum of American Art)

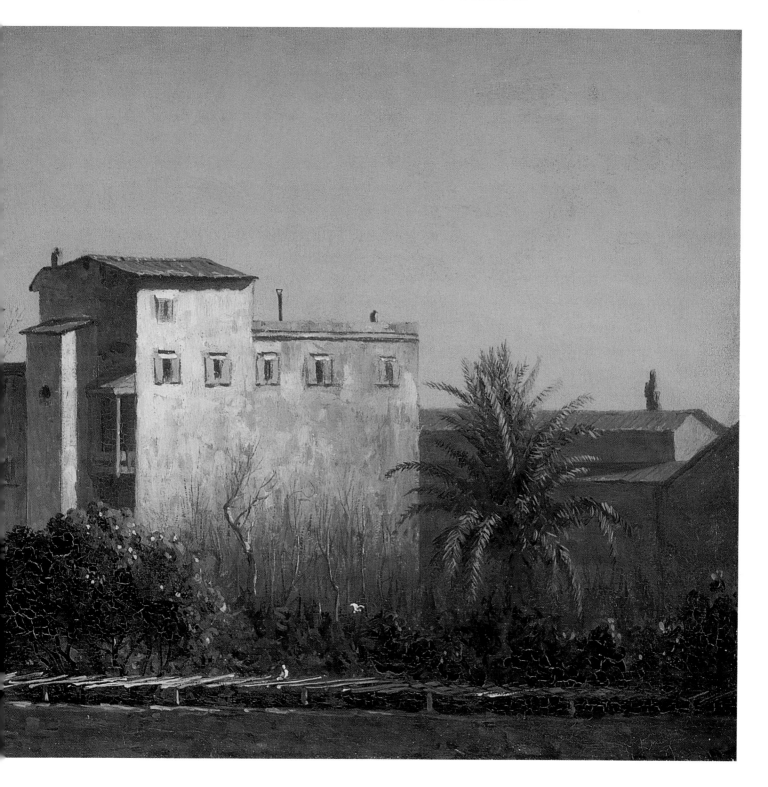

Codman represents the earlier of the Hudson River minor painters the death, in 1926, of Thomas Moran marks the end of the line and is the same year in which the great Impressionist Claude Monet also died.

CHARLES CODMAN (1800–1842)

In his short life, Charles Codman, born in Portland, Maine, became one of the early figures to represent the developing Hudson River School. He died six years before Thomas

Cole and his oeuvre, compared with most of his contemporaries, is small. His work is unsophisticated and his technique only adequate but he does represent the beginnings of the surge of Romanticism which only fully appeared after his death. He began by painting signs and fire screens as well as other objects requiring some decorative adornment. He received no formal training and little education and it was only by his own determination that he achieved the modest reputation he enjoys. (See plate 13.)

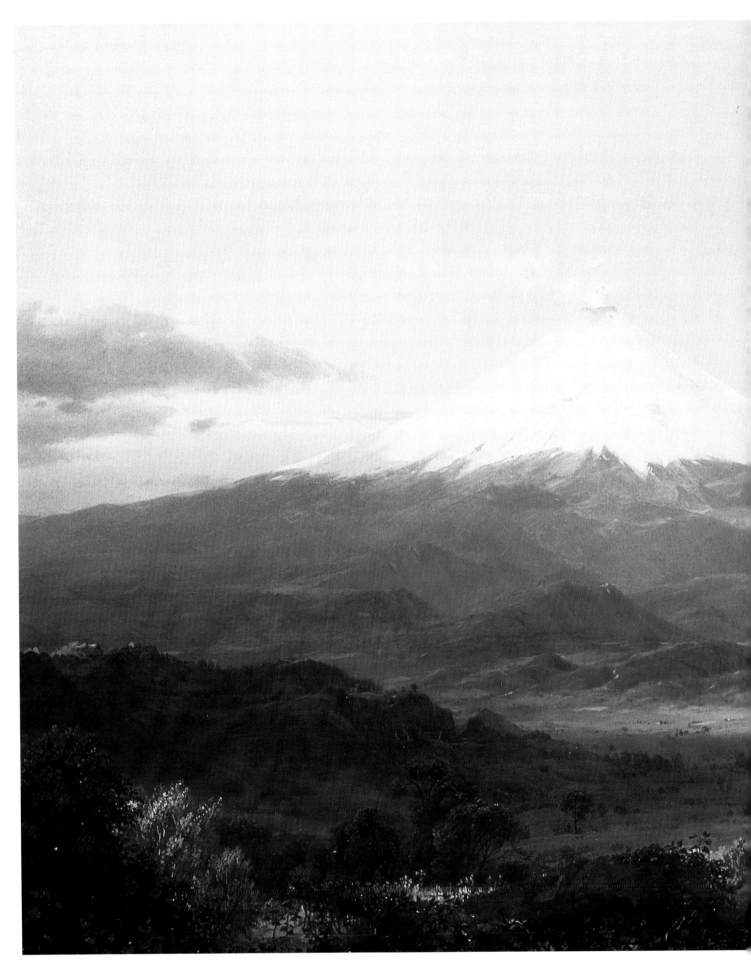

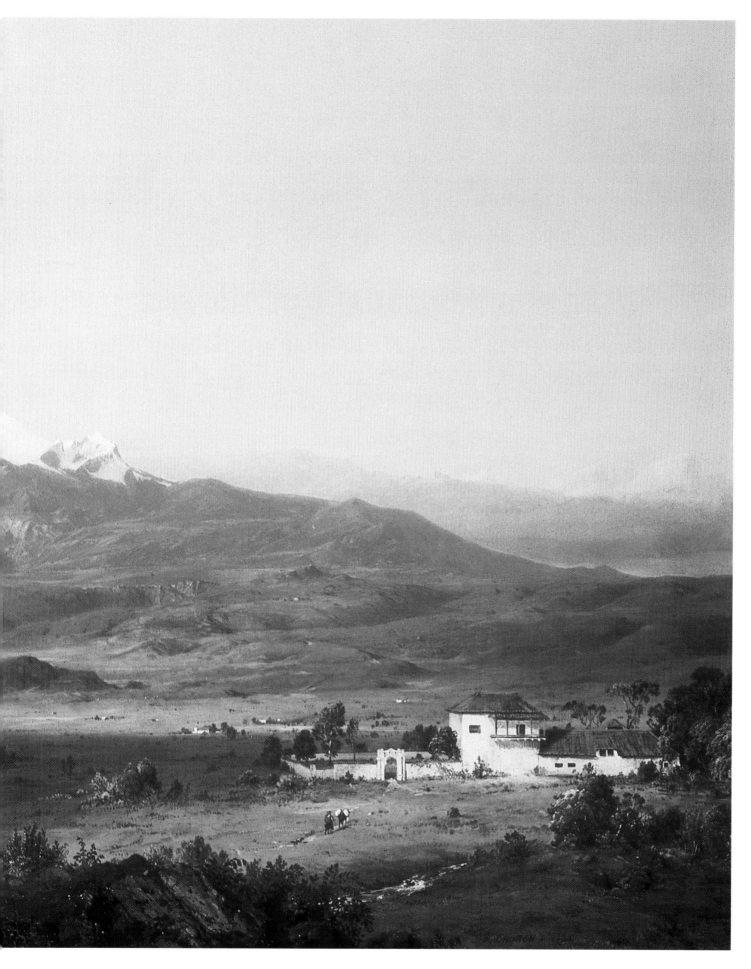

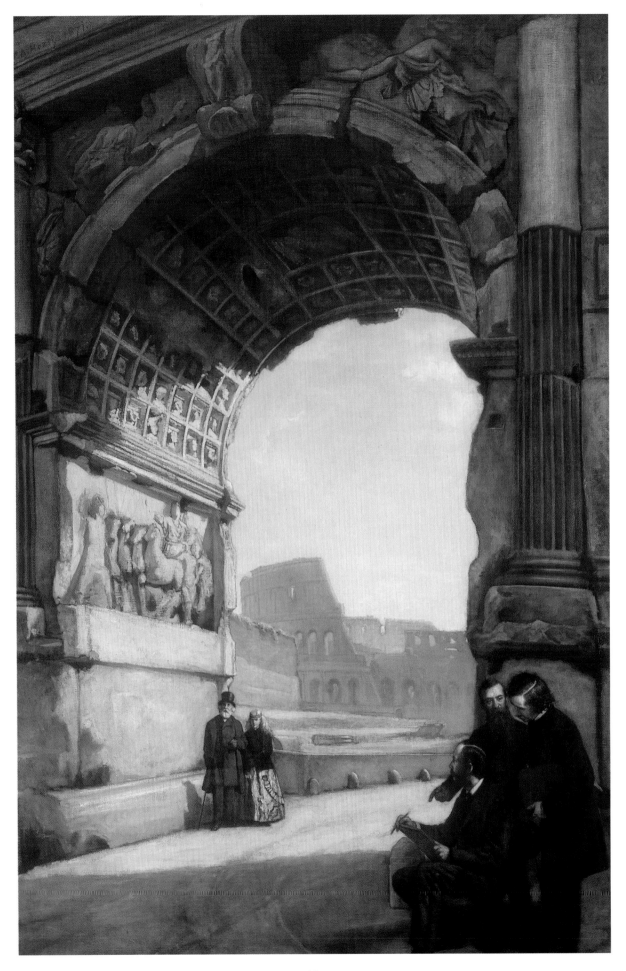

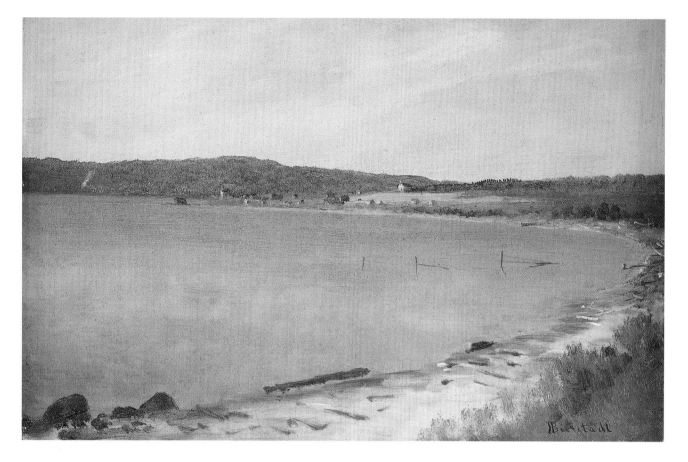

PLATE 41 opposite

Frederic Church and Jervis McEntee: The Arch of Titus (1871)

George Peter Alexander Healy

Oil on canvas, 74 x 49 inches (188 x 124.5cm)

(Courtesy The Newark Museum, New Jersey)

PLATE 42 above

San Francisco Bay (c.1871–1873)

Albert Bierstadt (1830–1902)

Oil on paper, 13³/₄ x 19 inches (35 x 48.5cm)

(Courtesy National Museum of American Art)

Pages 70–71

PLATE 43

The Amphitheater of Tusculum and the Albano Mountains, Rome (1860)

Thomas Worthington Whittredge (1820–1910)

Oil on canvas, 24 x 40 inches (61 x 101.6cm)

(Courtesy National Museum of American Art)

Coda

The above survey will have revealed what was initially claimed in the introduction. There is a great variety both of subject and treatment to be seen in the work inclusively described as the Hudson River School and, as noted earlier, this is a limited survey so that there are many other painters who justifiably could have been included in a longer and more exhaustive survey. But they would not have enlarged the range already included and might perhaps have diminished the impact of those that are, since it has to be admitted that despite the variety there is also a sameness in the paintings which becomes apparent in retrospective consideration. In a way that each of the Impressionists, for instance, shows such marked individualism that their work is instantly recognizable, that of the Hudson River painters is not always so and, biographical details apart, they are making very similar statements when using very different locations. Of course, this is not to say that these statements are not important or that the paintings do not give great visual pleasure now as they have to earlier generations. However, the moral and spiritual values, so important to them, are now less widely recognized or valued in present-day society and this element is not as easily seen. The result is that for the present observer part of the raison d'être of these works is lost or only dimly appreciated.

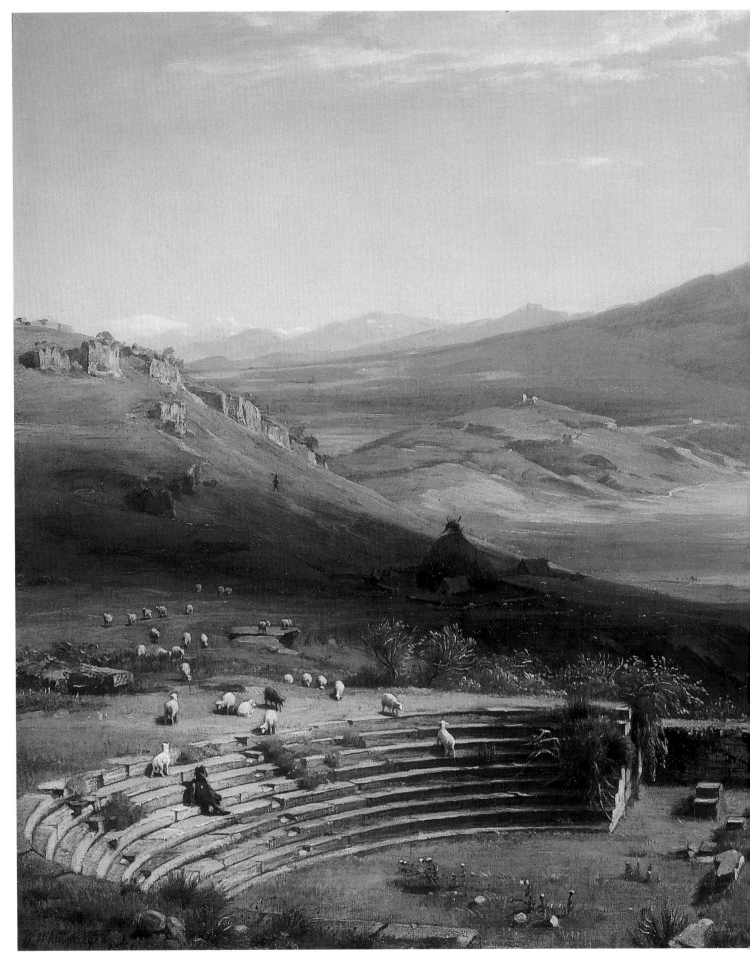

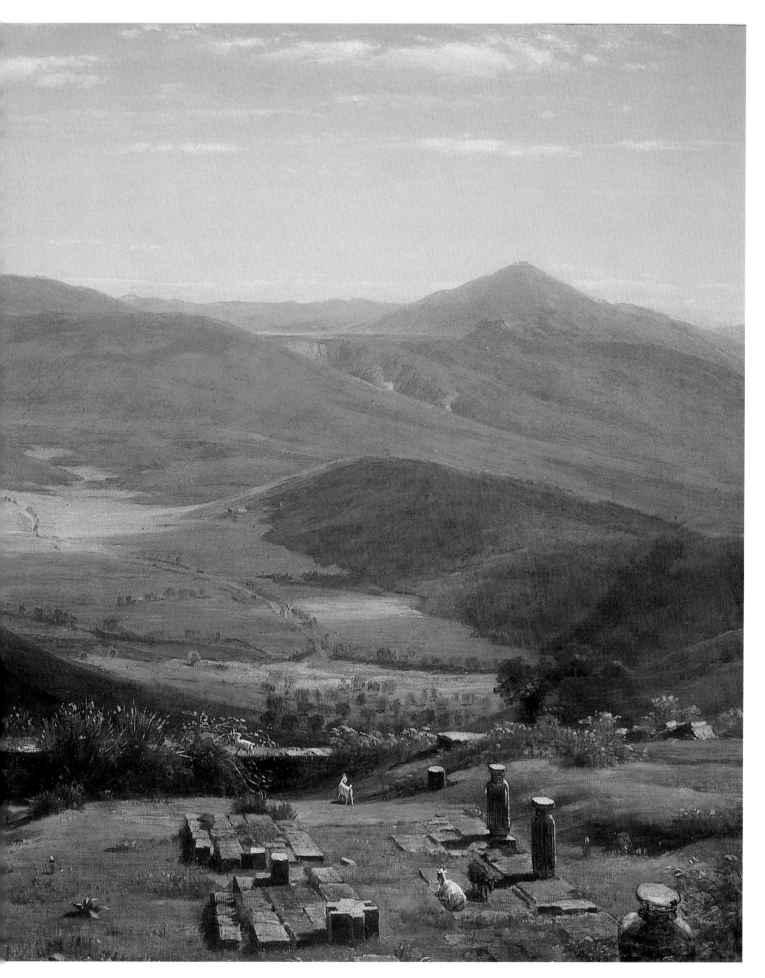

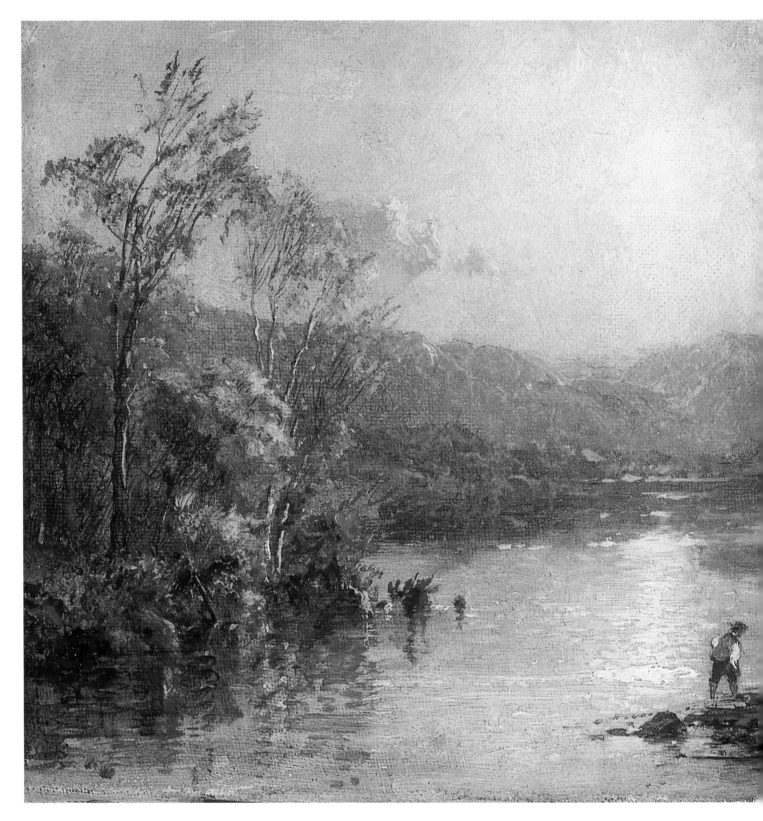

PLATE 44 above

Indian Summer (1886)

Jasper Francis Cropsey (1823–1900)

Oil on canvas, 7 x 13 inches (17.9 x 33cm)

(Courtesy National Museum of American Art)

Pages 74–75

PLATE 45

Harvest Time: Summer in Farmington Valley (c.1900)

Thomas Worthington Whittredge (1820–1910)

Oil on canvas, 15³/₁₆ x 22⁷/₈ inches (38.6 x 57cm)

(Courtesy Collection of the Newark Museum, New Jersey)

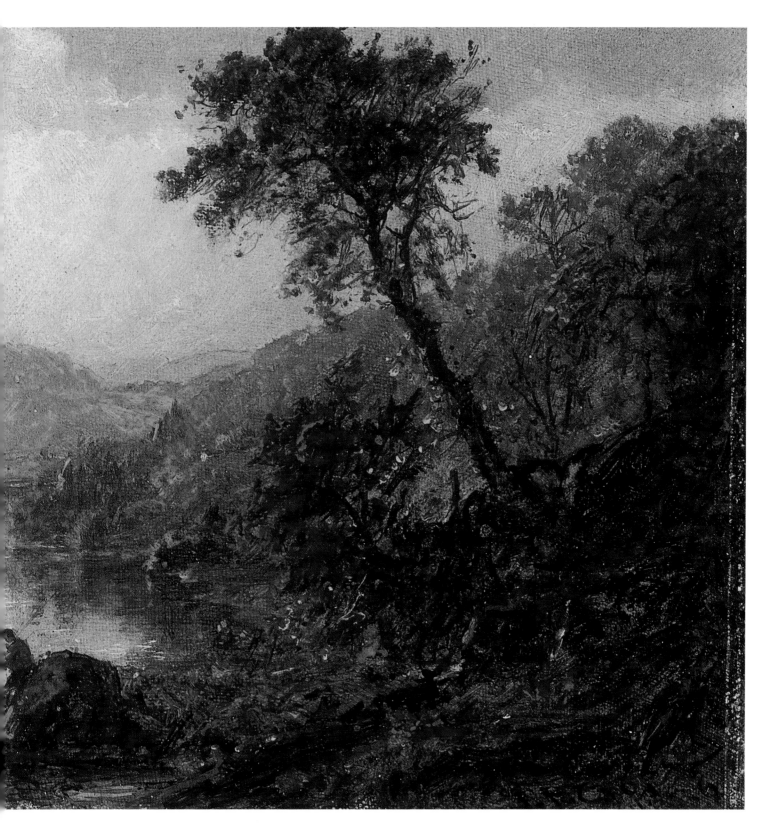

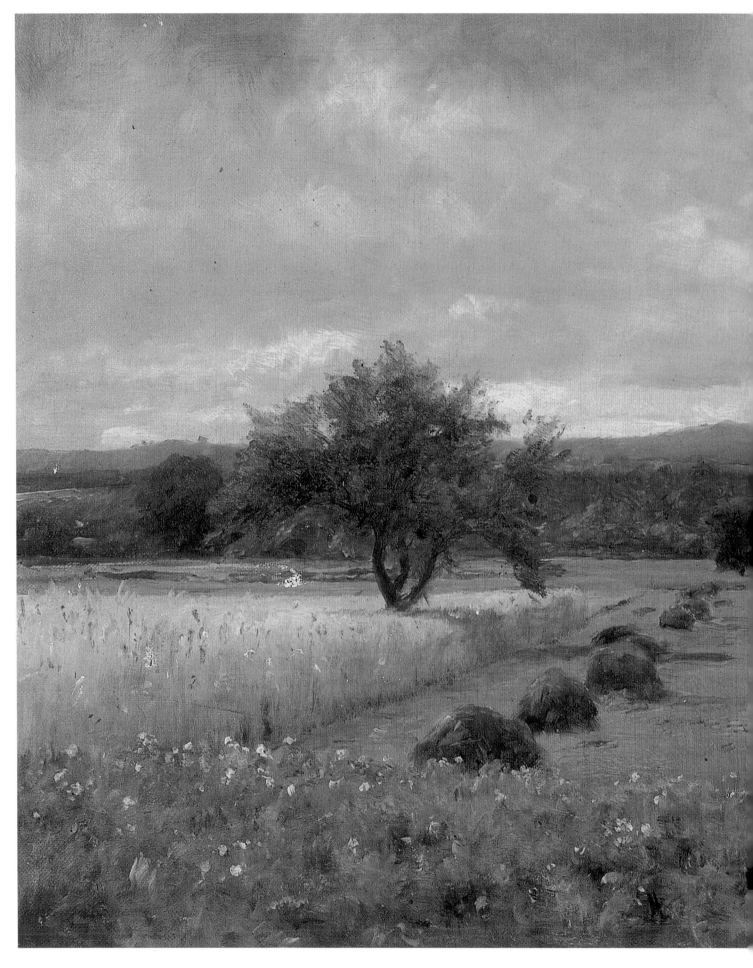

Kindred Spirits

The New York Public Library/Art Resource, New York

Catskill Creek

National Museum of American Art, Washington, D.C./Art Resource, New York

Marine off Big Rock

The Cummer Museum of Art and Gardens/SuperStock Inc.

Iceburgs

Private Collection/Art Resource, New York

Pompeii

National Museum of American Art, Washington, D.C./Art Resource, New York

The Coast of Genoa

National Museum of American Art, Washington, D.C./Art Resource, New York

Autumn – On the Hudson

National Museum of American Art, Washington, D.C./Art Resource, New York

The Lonely Cross – after a poem by Felicia Haymans

Musée d'Orsay/Art Resource, New York

View of Niagara Falls from the American Side

Private Collection/Art Resource, New York

The Architect's Dream

Toledo Museum of Art, Ohio

Cathedral Forest

Private Collection/Art Resource, New York

Valley Pasture

National Museum of American Art, Washington, D.C./Art Resource, New York

Landscape with Farm and Mountains

National Museum of American Art, Washington, D.C./Art Resource, New York

Aurora Borealis

National Museum of American Art, Washington, D.C./Art Resource, New York

Scene on the Hudson (Rip Van Winkle)

National Museum of American Art, Washington, D.C./Art Resource, New York

Approaching Storm: Beach near Newport

Museum of Fine Arts, Boston

Landscape with Rainbow

National Museum of American Art, Washington, D.C./Art Resource, New York

Lake George

The Metropolitan Museum of Art, New York, bequest of Maria de Witt Jesup, 1915

The Birches of the Catskills

National Museum of American Art, Washington, D.C./Art Resource, New York

The Course of Empire: Consummation

The New-York Historical Society, New York

River View with Hunters and Dogs

National Museum of American Art, Washington, D.C./Art Resource, New York

Cliffs of the Upper Colorado River, Wyoming Territory

National Museum of American Art, Washington, D.C./Art Resource, New York

Whiteface Mountain from Lake Placid

National Museum of American Art, Washington, D.C./Art Resource, New York

Desert Rock Lighthouse

The Newark Museum, Newark, New Jersey/Art Resource, New York

Woodland Glen

National Museum of American Art, Washington, D.C./Art Resource, New York

The Wetterhorn

The Newark Museum, Newark, New Jersey/Art Resource, New York

The Oxbow

The Metropolitan Museum of Art, New Yrok, Gift of Mrs Russell Sage, 1908

Western Landscape

The Newark Museum, Newark, New Jersey/Art Resource, New York

Loch Long, 1867

National Museum of American Art, Washington, D.C./Art Resource, New York

Snow Scene with Buffaloes

Private Collection/Art Resource, New York

Along the Hudson

National Museum of American Art, Washington, D.C./Art Resource, New York

Dover Plain, Dutchess County, New York

National Museum of American Art, Washington, D.C./Art Resource, New York

The Subsiding of the Waters of the Deluge

National Museum of American Art, Washington, D.C./Art Resource, New York

Landing of Columbus

The Newark Museum, Newark, New Jersey/Art Resource, New York

Forest Interior with Stream

National Museum of American Art, Washington, D.C./Art Resource, New York

Waterfall on Mont-Morency

National Museum of American Art, Washington, D.C./Art Resource, New York

The Wetterhorn, Switzerland

Private Collection/Art Resource, New York

Pompeii

National Museum of American Art, Washington, D.C./Art Resource, New York

Villa Malta, Rome

National Museum of American Art, Washington, D.C./Art Resource, New York

Cotopaxi

National Museum of American Art, Washington, D.C./Art Resource, New York

Frederic Church and Jervis McEntee: The Arch of Titus

The Newark Museum, Newark, New Jersey/Art Resource, New York

San Francisco Bay

National Museum of American Art, Washington, D.C./Art Resource, New York

The Amphitheater of Tusculum and the Albano Mountains, Rome

National Museum of American Art, Washington, D.C./Art Resource, New York

Indian Summer

National Museum of American Art, Washington, D.C./Art Resource, New York

Harvest Time: Summer in Farmington Valley

The Newark Museum, Newark, New Jersey/Art Resource, New York